CREATIVE STRUGGLE

CREATIVE STRUGGLE

ILLUSTRATED ADVICE FROM
MASTERS OF CREATIVITY

GAVIN AUNG THAN

Andrews McMeel
PUBLISHING®

Andrews McMeel Publishing
a division of Andrews McMeel Universal
1130 Walnut Street, Kansas City, Missouri 64106

www.andrewsmcmeel.com

18 19 20 21 22 TEN 10 9 8 7 6 5 4 3 2 1

ISBN: 978-1-4494-8722-5

Library of Congress Control Number: 2017949987

Editor: Dorothy O'Brien
Creative Director: Tim Lynch
Production Editor: Amy Strassner
Production Manager: Tamara Haus

ATTENTION: SCHOOLS AND BUSINESSES

are available at quantity discounts with bulk purchase for educational, tional use. For information, please e-mail the Andrews McMeel Publishing nt: specialsales@amuniversal.com.

Contents

Introduction

Self-doubt, imposter syndrome, procrastination, creative block, fear—these are roadblocks regular creative people deal with every day. But what about the masters? The creative titans of history. The icons. Surely they never had to waste time with those barriers, right? Wrong. They were just as insecure as the rest of us. Just as prone to doubt, depression, addiction, and perfectionism. But they were able to overcome their inner-critic and ended up using their creativity to change the world. You might not have such a lofty goal, but, hey, it's nice to know you're not alone.

VINCENT VAN GOGH

THE BLANK CANVAS

JUST SLAP ANYTHING ON WHEN YOU SEE A BLANK CANVAS STARING YOU IN THE FACE LIKE SOME *IMBECILE*.

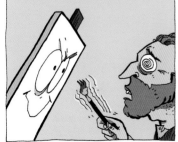

YOU DON'T KNOW HOW PARALYZING THAT IS, THAT STARE OF A BLANK CANVAS IS, WHICH SAYS TO THE PAINTER...

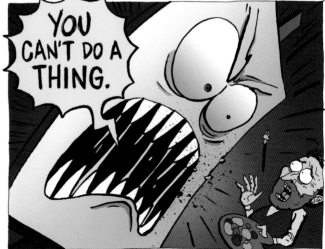

YOU *CAN'T DO A THING.*

THE CANVAS HAS AN IDIOTIC STARE AND *MESMERIZES* SOME PAINTERS SO MUCH...

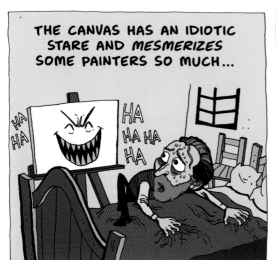

...THAT THEY TURN INTO IDIOTS *THEMSELVES.*

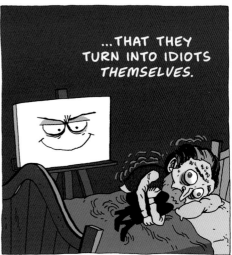

MANY PAINTERS ARE *AFRAID* IN FRONT OF THE BLANK CANVAS.

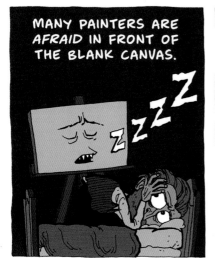

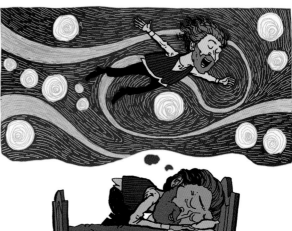

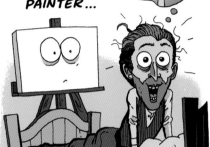

BUT THE BLANK CANVAS IS AFRAID OF THE REAL, PASSIONATE PAINTER...

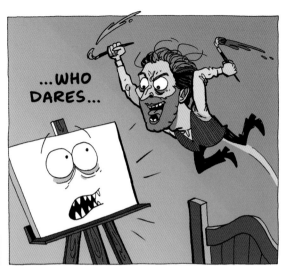

...WHO DARES...

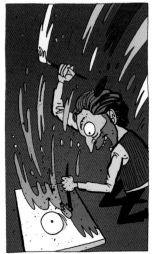

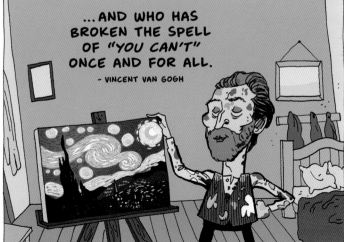

...AND WHO HAS BROKEN THE SPELL OF "YOU CAN'T" ONCE AND FOR ALL.

- VINCENT VAN GOGH

9

"It constantly remains a source of disappointment to me that my drawings are not yet what I want them to be. The difficulties are indeed numerous and great, and cannot be overcome at once. To make progress is a kind of miner's work; it doesn't advance as quickly as one would like, and as others also expect, but as one stands before such a task, the basic necessities are patience and faithfulness."

—Vincent van Gogh

Not many others have struggled more for their art than Vincent van Gogh. Although he had a passion for art since a child, Van Gogh's first career choice was to become a minister. After studying for a year, Van Gogh failed his entrance exam to the School of Theology in Amsterdam and later the Church of Belgium. Unable to join the church, Van Gogh decided he would devote himself to art. Although his work was exhibited in his later years, he received no recognition for his art during his life, lived in constant poverty, and died having only sold one of his paintings.

Van Gogh was the epitome of the "tortured artist." He lived a desperately sad life filled with disappointment. Besides failing to become a minster, Van Gogh had a

disastrous love life, his friendships never lasted (after threatening friend and fellow artist Paul Gauguin with a razor blade, Van Gogh famously cut off his own earlobe), and his art career never went anywhere. He even failed at committing suicide—when Van Gogh shot himself in the chest with a pistol, the bullet missed his vital organs, and he was able to walk back to his house where he rested and smoked his pipe. He eventually died the next day after an infection took hold.

Van Gogh was in and out of mental asylums his whole life, and it's unsure whether or not he suffered from bipolar disorder, schizophrenia, epilepsy, or some other kind of mental illness. Throughout all the difficulties in his life, the only thing that gave Van Gogh any kind of peace was the passion he had for his art:

"Though I am often in the depths of misery, there is still calmness, pure harmony, and music inside me. I see paintings or drawings in the poorest cottages, in the dirtiest corners. And my mind is driven toward these things with an irresistible momentum."

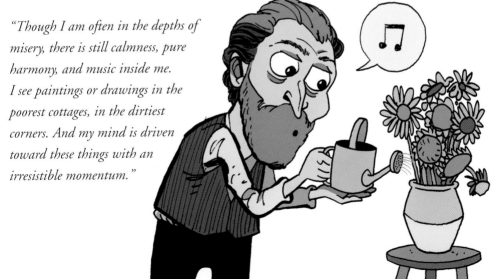

ALBERT EINSTEIN

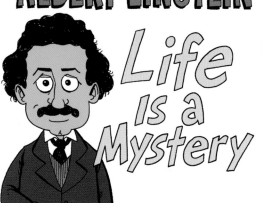

Life is a Mystery

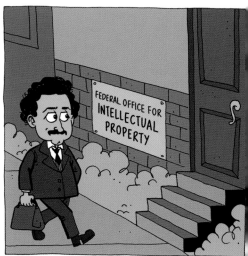

FEDERAL OFFICE FOR INTELLECTUAL PROPERTY

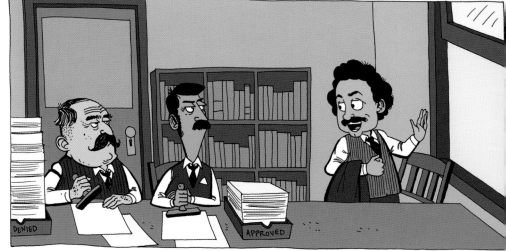

DENIED

APPROVED

THE MOST BEAUTIFUL AND DEEPEST EXPERIENCE A MAN CAN HAVE IS THE SENSE OF THE *MYSTERIOUS*.

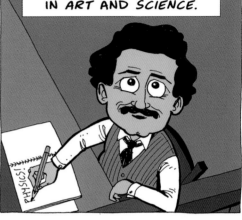

IT IS THE UNDERLYING PRINCIPLE OF *RELIGION* AS WELL AS OF ALL SERIOUS ENDEAVOR IN *ART* AND *SCIENCE*.

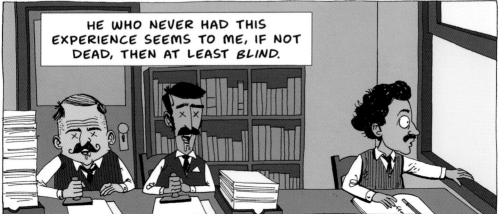

HE WHO NEVER HAD THIS EXPERIENCE SEEMS TO ME, IF NOT DEAD, THEN AT LEAST *BLIND*.

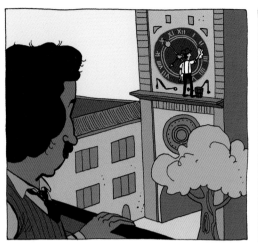
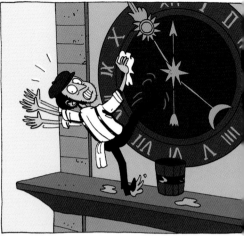
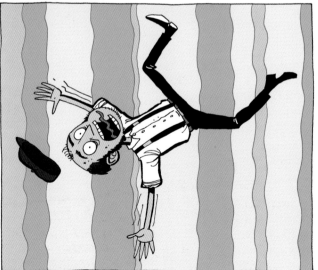
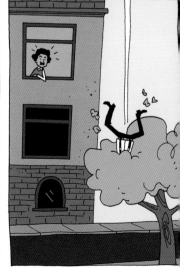

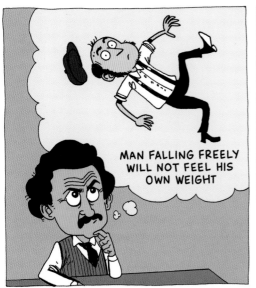

MAN FALLING FREELY WILL NOT FEEL HIS OWN WEIGHT

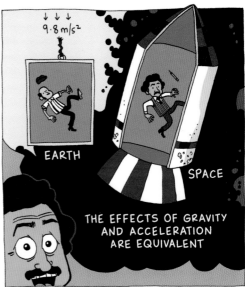

9.8 m/s^2

EARTH

SPACE

THE EFFECTS OF GRAVITY AND ACCELERATION ARE EQUIVALENT

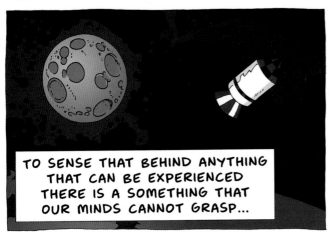

TO SENSE THAT BEHIND ANYTHING THAT CAN BE EXPERIENCED THERE IS A SOMETHING THAT OUR MINDS CANNOT GRASP...

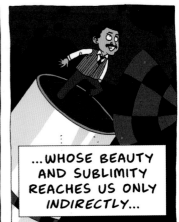

...WHOSE BEAUTY AND SUBLIMITY REACHES US ONLY INDIRECTLY...

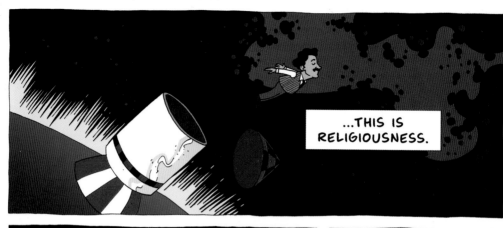

...THIS IS RELIGIOUSNESS.

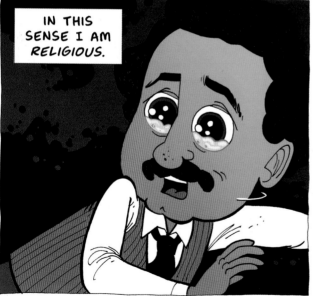

IN THIS SENSE I AM *RELIGIOUS*.

TO ME IT SUFFICES TO WONDER AT THESE SECRETS AND TO ATTEMPT HUMBLY TO GRASP WITH MY MIND...

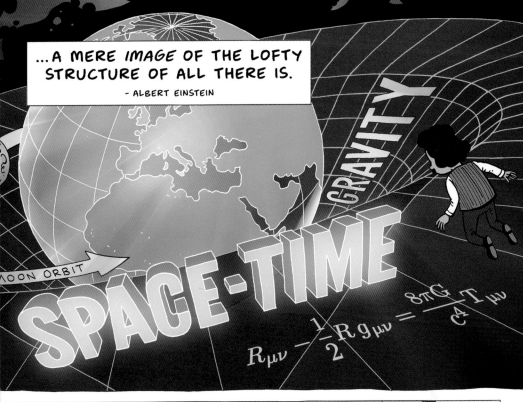

...A MERE IMAGE OF THE LOFTY STRUCTURE OF ALL THERE IS.

- ALBERT EINSTEIN

> "The state of mind which enables a man to do work of this kind is akin to that of the religious worshiper or the lover; the daily effort comes from no deliberate intention or program, but straight from the heart."
>
> —Albert Einstein

Albert Einstein was desperate. After graduating with a teaching diploma in 1900, he was having a hard time finding a job as an assistant professor. With a child on the way, Einstein survived with the help of his parents and the odd tutoring job. Finally, after two years of jobless despair, a friend managed to hook him up with a job at the Swiss Federal Office for Intellectual Property assessing patents. It wasn't the academic job he was hoping for, but at this point, Einstein was just happy to have found work.

There, Einstein would have the seven most creative years of his life. The patent office duties were a breeze and he could get a full day's work done in two or three hours. That allowed him to work on his own physics ideas for the rest of the day. It was while in this job, in 1905, that the twenty-six-year-old unknown amateur physicist produced the greatest MVP season of any physicist in history, publishing four papers that changed the world, including his theory of special relativity. It's now known as Einstein's "miracle year."

Most of Einstein's important discoveries came from what he called Gedankenexperiments, which were visual thought experiments. *"What would it be like riding along a beam of light? What if two lightning bolts struck a moving train simultaneously?"* It was in 1907, while working at the patent office, where Einstein had his favorite: *"If a person falls freely, he would not feel his own weight."* Scientific lore has it that Einstein actually saw a man fall while looking out his office window. The idea led him to a further thought experiment: If the falling man was in an enclosed elevator that had its cord cut he would experience weightlessness. But his experience would be no different from a man floating in an enclosed chamber in outer space. If the elevator was stationary on earth, the man would be inside standing normally. But if the chamber in space was pulled upward at the same acceleration as Earth's gravity, again, there would be no difference felt by the man inside. Therefore, there was no difference between the effects of gravity and acceleration.

This idea, which Einstein called the equivalence principle, led to his theory of general relativity in 1915. Later, Einstein would recall the image of the man falling as being the *"happiest thought of my life."*

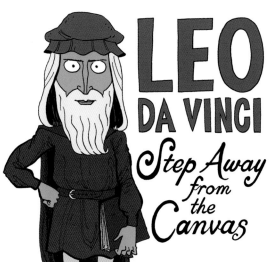

LEO DA VINCI

Step Away from the Canvas

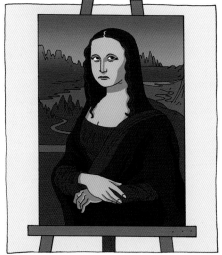

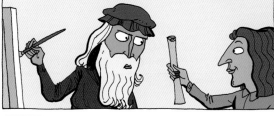

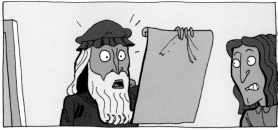

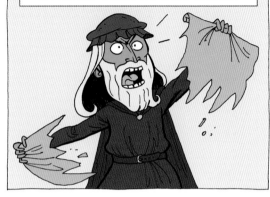

WE KNOW VERY WELL THAT ERRORS ARE BETTER RECOGNIZED IN THE WORKS OF *OTHERS* THAN IN OUR OWN...

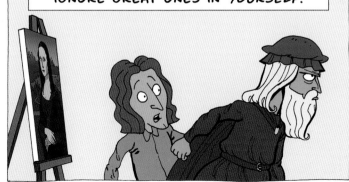

...AND THAT OFTEN, WHILE REPROVING LITTLE FAULTS IN *OTHERS*, YOU MAY IGNORE GREAT ONES IN *YOURSELF.*

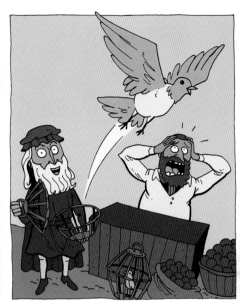

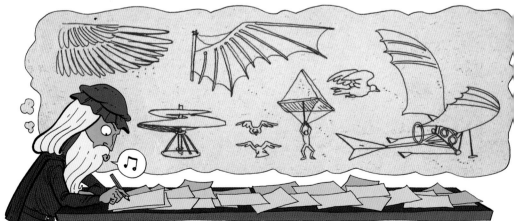

22

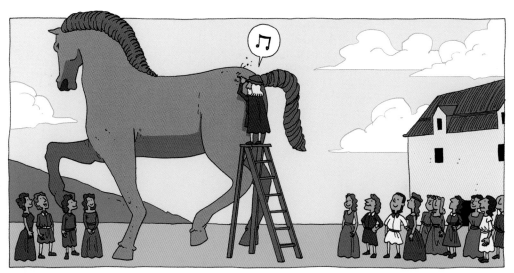

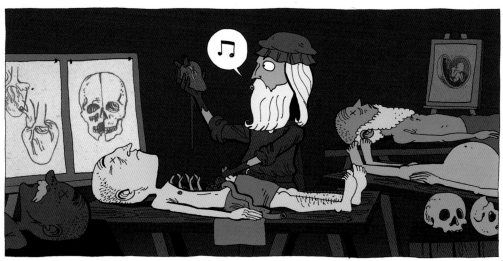

23

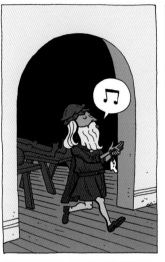

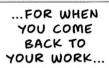
...FOR WHEN YOU COME BACK TO YOUR WORK...

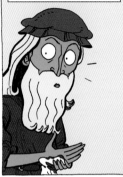

...YOUR JUDGMENT WILL BE SURER.

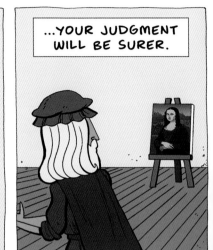

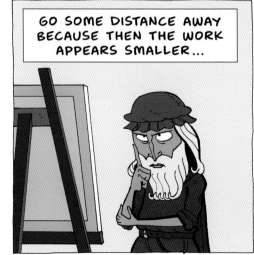
GO SOME DISTANCE AWAY BECAUSE THEN THE WORK APPEARS SMALLER...

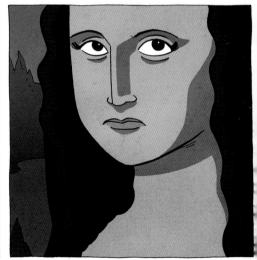

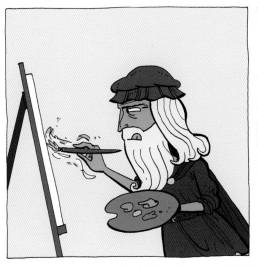

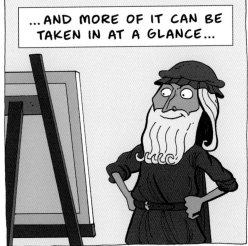

...AND MORE OF IT CAN BE TAKEN IN AT A GLANCE...

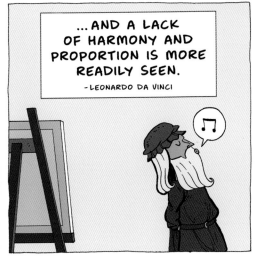

...AND A LACK OF HARMONY AND PROPORTION IS MORE READILY SEEN.

-LEONARDO DA VINCI

> "When the work exceeds the ideal of the artist, the artist makes scant progress, and when the work falls short of his ideal, it never ceases to improve."
> —Leonardo da Vinci

Is it a bit harsh to say that super genius and the ultimate Renaissance man, Leonardo da Vinci, was an *underachiever*? Maybe, but hear me out first. Leo's brilliant, restless mind was a blessing and a curse. He seemed to be bursting with so many ideas in such a variety of disciplines that it actually inhibited him from realizing his full potential. For starters, he got bored easily and didn't finish many of his paintings. Once Da Vinci had a concept figured out and he could see the finished painting in his mind, he often just abandoned it. Three of his most famous works, *The Adoration of the Magi, St. Jerome in the Wilderne*ss, and *The Virgin and Child with St. Anne and St. John the Baptist* are all incomplete preliminary paintings.

At thirty, Da Vinci walked away from a safe career as a painter in Florence and moved to Milan to seek new challenges. There he worked on his most famous unfinished piece of art: *The Gran Cavallo*, a twenty-four-foot bronze horse statue. Da Vinci spent seventeen years working on the horse (among other projects), only managing to complete a huge clay model.

Da Vinci was a compulsive notetaker, filling over 15,000 pages with sketches, designs, and thoughts on art and life. He sketched elaborate war machines, tanks, siege weapons, bridges, underwater diving suits, helicopters, and parachutes. He was obsessed with birds and flight, designed fantastical flying machines, and spent years conducting an exhaustive study of human anatomy. His ideas were *hundreds* of years ahead of his time, but for all the brilliance included in his notebooks, Da Vinci never published any of it. If they were published in his lifetime, they would have revolutionized engineering and medicine, and Da Vinci would have been heralded as the greatest scientist of his day, not just a great artist.

Always a perfectionist, Da Vinci was never satisfied with his work, always working on multiple projects at the same time over a number of years. He started the *Mona Lisa* in 1503 and kept it with him as he moved from Italy to France, working on it until his death in 1519. On his deathbed, Da Vinci apparently said, *"I have offended God and mankind because my work didn't reach the quality it should have."* Yes, even the undisputed greatest genius in history had self-doubt about his work.

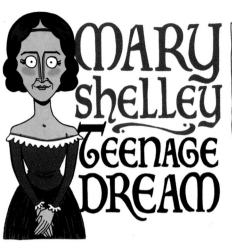

MARY SHELLEY TEENAGE DREAM

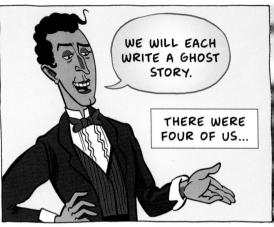

WE WILL EACH WRITE A GHOST STORY.

THERE WERE FOUR OF US...

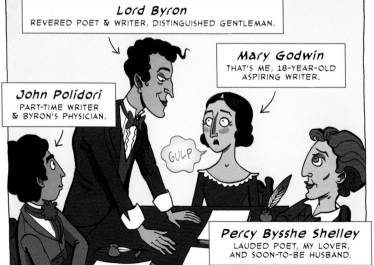

Lord Byron
REVERED POET & WRITER, DISTINGUISHED GENTLEMAN.

Mary Godwin
THAT'S ME, 18-YEAR-OLD ASPIRING WRITER.

John Polidori
PART-TIME WRITER & BYRON'S PHYSICIAN.

GULP

Percy Bysshe Shelley
LAUDED POET, MY LOVER, AND SOON-TO-BE HUSBAND.

I BUSIED MYSELF TO THINK OF A STORY. ONE WHICH WOULD SPEAK TO THE MYSTERIOUS FEARS OF OUR NATURE, AND AWAKEN THRILLING HORROR.

ONE TO MAKE THE READER DREAD TO LOOK ROUND, TO CURDLE THE BLOOD, AND QUICKEN THE BEATINGS OF THE HEART.

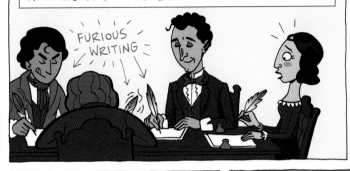

FURIOUS WRITING

I THOUGHT AND PONDERED.

VAINLY.

I FELT THAT BLANK INCAPABILITY OF INVENTION WHICH IS THE GREATEST MISERY OF AUTHORSHIP, WHEN DULL NOTHING REPLIES TO OUR ANXIOUS INVOCATIONS.

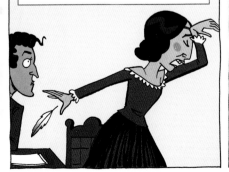

"HAVE YOU THOUGHT OF A STORY?" I WAS ASKED EACH MORNING, AND EACH MORNING I WAS FORCED TO REPLY WITH A MORTIFYING NEGATIVE.

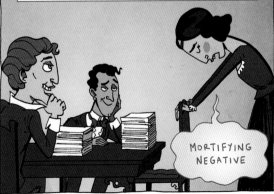

MORTIFYING NEGATIVE

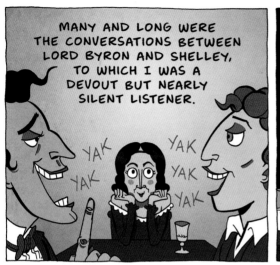

MANY AND LONG WERE THE CONVERSATIONS BETWEEN LORD BYRON AND SHELLEY, TO WHICH I WAS A DEVOUT BUT NEARLY SILENT LISTENER.

YAK YAK YAK YAK YAK

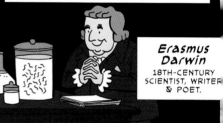

THEY TALKED OF THE EXPERIMENTS OF DR. DARWIN, WHO PRESERVED A PIECE OF VERMICELLI IN A GLASS CASE TILL BY SOME EXTRAORDINARY MEANS IT BEGAN TO MOVE WITH VOLUNTARY MOTION.

Erasmus Darwin
18TH-CENTURY SCIENTIST, WRITER & POET.

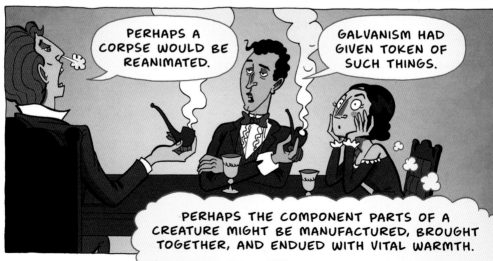

PERHAPS A CORPSE WOULD BE REANIMATED.

GALVANISM HAD GIVEN TOKEN OF SUCH THINGS.

PERHAPS THE COMPONENT PARTS OF A CREATURE MIGHT BE MANUFACTURED, BROUGHT TOGETHER, AND ENDUED WITH VITAL WARMTH.

NIGHT WANED UPON THIS TALK, AND EVEN THE WITCHING HOUR HAD GONE BY, BEFORE WE RETIRED TO REST.

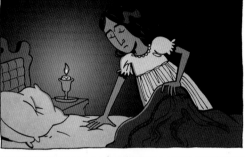

WHEN I PLACED MY HEAD ON MY PILLOW, I DID NOT SLEEP, NOR COULD I BE SAID TO THINK.

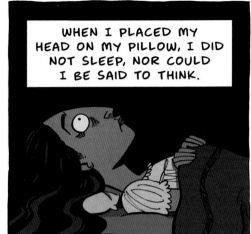

MY IMAGINATION, UNBIDDEN, POSSESSED AND GUIDED ME, GIFTING THE SUCCESSIVE IMAGES THAT AROSE IN MY MIND WITH A VIVIDNESS FAR BEYOND THE USUAL BOUNDS OF REVERIE.

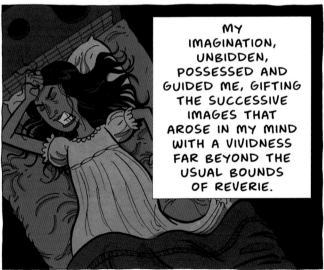

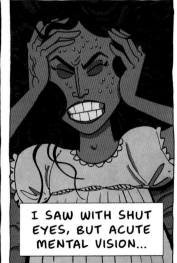

I SAW WITH SHUT EYES, BUT ACUTE MENTAL VISION...

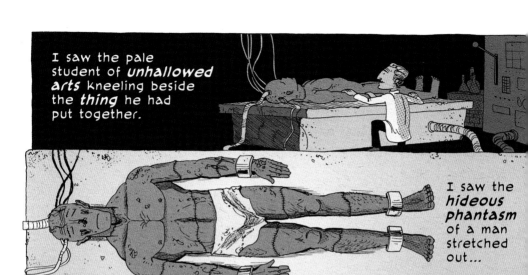

I saw the pale student of *unhallowed arts* kneeling beside the *thing* he had put together.

I saw the *hideous phantasm* of a man stretched out...

...and then, on the working of some *powerful* engine, show signs of life, and stir with an *uneasy, half vital motion.*

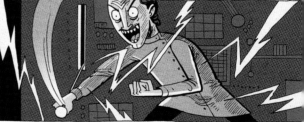

Frightful must it be, for supremely frightful would be the effect of any human endeavor to mock the stupendous mechanism of the *Creator of the world.*

His success would *terrify* the artist.

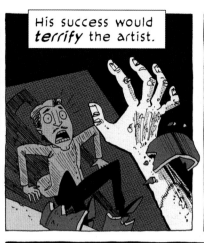

He would rush away from his odious handiwork, *horror-stricken.*

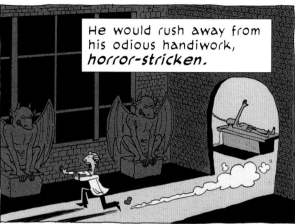

He would hope that, left to itself, the slight *spark* of life which he had communicated would *fade*, that this thing, which had received such imperfect animation, would *subside into dead matter.*

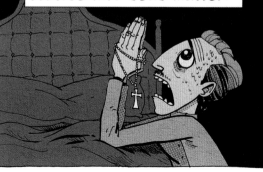

And he might sleep in the belief that the silence of the grave would quench forever the transient existence of the *hideous corpse* which he had looked upon as the *cradle of life.*

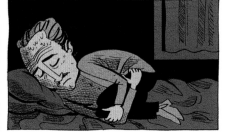

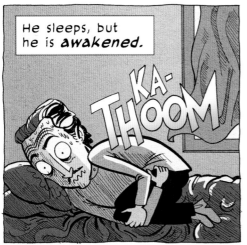

He sleeps, but he is **awakened.**

KA-THOOM

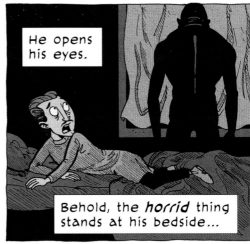

He opens his eyes.

Behold, the *horrid* thing stands at his bedside...

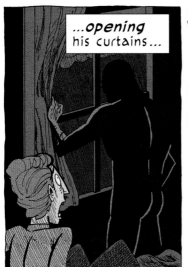

...*opening* his curtains...

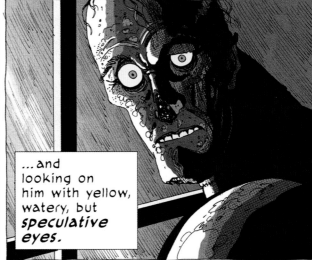

...and looking on him with yellow, watery, but *speculative eyes.*

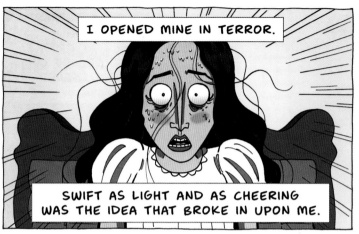

I OPENED MINE IN TERROR.

SWIFT AS LIGHT AND AS CHEERING WAS THE IDEA THAT BROKE IN UPON ME.

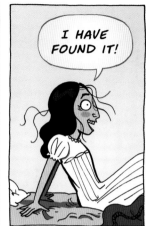

I HAVE FOUND IT!

WHAT TERRIFIED ME WILL TERRIFY OTHERS, AND I NEED ONLY DESCRIBE THE SPECTER WHICH HAD HAUNTED MY MIDNIGHT PILLOW.

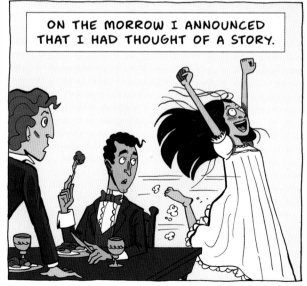

ON THE MORROW I ANNOUNCED THAT I HAD THOUGHT OF A STORY.

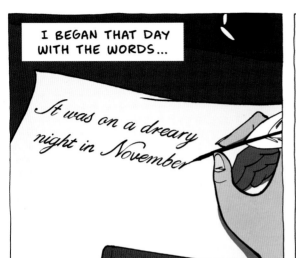

I BEGAN THAT DAY WITH THE WORDS...

It was on a dreary night in November

...MAKING ONLY A TRANSCRIPT OF THE GRIM TERRORS OF MY WAKING DREAM.

- MARY SHELLEY

Frankenstein
or,
The Modern Prometheus

Mary Shelley

Mary Shelley's ghost story breakthrough occurred at the most famous summer retreat in literary history. In May 1816, four Brits were vacationing together in Lake Geneva, Switzerland. The acclaimed poet Lord Byron was there with his personal physician, John Polidori. They met up with another famed poet, Percy Bysshe Shelley, and his eighteen-year-old mistress, Mary Wollstonecraft Godwin. The weather in Lake Geneva was lousy, so the group spent most of their time cooped up inside talking politics and reading old ghost stories. Byron had the idea to hold a contest where each person would write their own ghost story. Funnily enough, the two lauded professionals, Byron and Shelley, ended up writing stories that have been forgotten by history. It was the two amateurs, Mary and Polidori, who wrote tales that have left a lasting legacy. (Polidori would end up writing *The Vampyre*, the first modern vampire story.)

Mary intended her effort only be a short story, but at the encouragement of Shelley, she extended it into a novel. *Frankenstein; or, The Modern Prometheus* was first published in 1818, becoming what many consider the first science-fiction story and introduced the world to literature's most famous monster.

MARIE CURIE

Our Happy Place

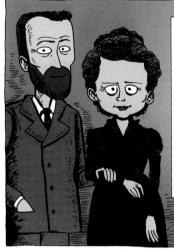

WITH MY MARRIAGE THERE BEGAN FOR ME A *NEW EXISTENCE* ENTIRELY DIFFERENT FROM THE SOLITARY LIFE THAT I HAD KNOWN DURING THE PRECEDING YEARS.

MY HUSBAND AND I WERE SO CLOSELY *UNITED* BY OUR AFFECTION AND OUR COMMON WORK THAT WE PASSED NEARLY ALL OF OUR TIME TOGETHER.

WE HAD DISCOVERED THE EXISTENCE OF THE REMARKABLE NEW ELEMENTS...

Po Polonium

Ra Radium

BUT IT WAS CHIEFLY BY THEIR RADIANT PROPERTIES THAT THESE NEW SUBSTANCES WERE DISTINGUISHED FROM THE BISMUTH AND BARIUM WITH WHICH THEY WERE MIXED IN MINUTE QUANTITIES.

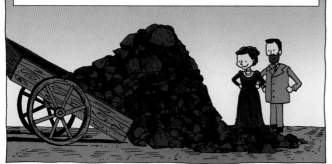

WE HAD STILL TO *SEPARATE* THEM AS PURE ELEMENTS.

WE HAD *NO MONEY, NO SUITABLE LABORATORY, NO PERSONAL HELP* FOR OUR GREAT AND DIFFICULT UNDERTAKING.

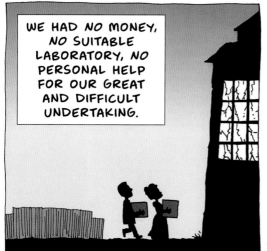

THE SCHOOL OF PHYSICS COULD GIVE US NO SUITABLE PREMISES, BUT FOR LACK OF ANYTHING BETTER...

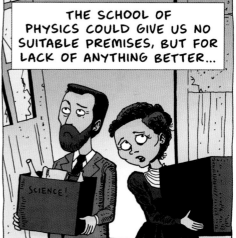

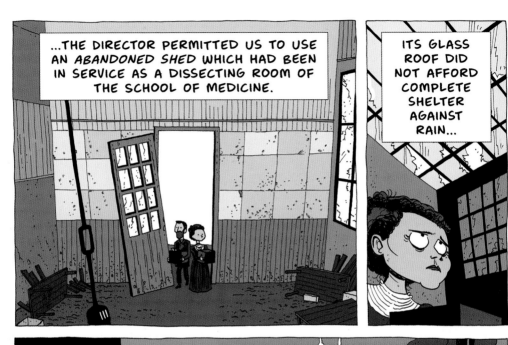

...THE DIRECTOR PERMITTED US TO USE AN *ABANDONED SHED* WHICH HAD BEEN IN SERVICE AS A DISSECTING ROOM OF THE SCHOOL OF MEDICINE.

ITS GLASS ROOF DID NOT AFFORD COMPLETE SHELTER AGAINST RAIN...

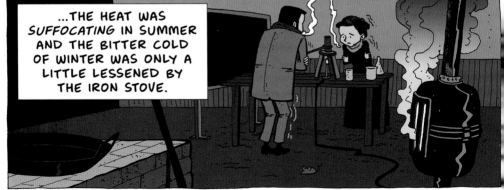

...THE HEAT WAS *SUFFOCATING* IN SUMMER AND THE BITTER COLD OF WINTER WAS ONLY A LITTLE LESSENED BY THE IRON STOVE.

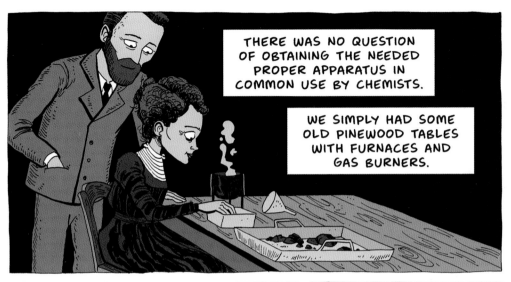

THERE WAS NO QUESTION OF OBTAINING THE NEEDED PROPER APPARATUS IN COMMON USE BY CHEMISTS.

WE SIMPLY HAD SOME OLD PINEWOOD TABLES WITH FURNACES AND GAS BURNERS.

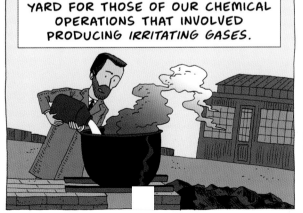

WE HAD TO USE THE ADJOINING YARD FOR THOSE OF OUR CHEMICAL OPERATIONS THAT INVOLVED PRODUCING *IRRITATING GASES.*

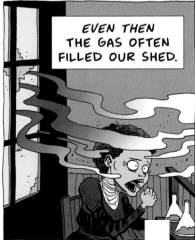

EVEN THEN THE GAS OFTEN FILLED OUR SHED.

YET IT WAS IN THIS MISERABLE OLD SHED THAT WE PASSED THE *BEST* AND *HAPPIEST* YEARS OF OUR LIFE, DEVOTING OUR ENTIRE DAYS TO OUR WORK.

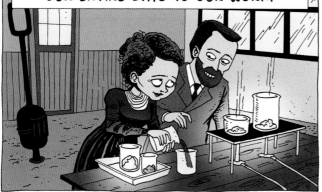

OFTEN I HAD TO PREPARE OUR LUNCH IN THE SHED, SO AS NOT TO INTERRUPT SOME PARTICULARLY IMPORTANT OPERATION.

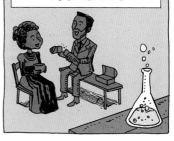

SOMETIMES I HAD TO SPEND A WHOLE DAY MIXING A *BOILING* MASS WITH A HEAVY IRON ROD NEARLY AS LARGE AS MYSELF.

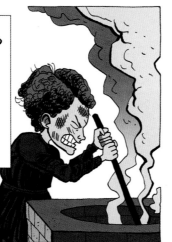

I WOULD BE BROKEN WITH *FATIGUE* AT THE DAY'S END.

OTHER DAYS, ON THE CONTRARY, THE WORK WOULD BE A MOST MINUTE AND DELICATE *FRACTIONAL CRYSTALLIZATION*, IN THE EFFORT TO CONCENTRATE THE RADIUM.

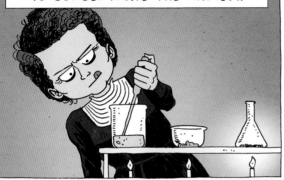

I WAS THEN ANNOYED BY THE FLOATING DUST OF IRON AND COAL FROM WHICH I COULD NOT PROTECT MY PRECIOUS PRODUCTS.

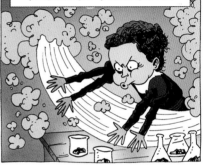

BUT I SHALL NEVER BE ABLE TO EXPRESS THE JOY OF THE *UNTROUBLED QUIETNESS* OF THIS ATMOSPHERE OF RESEARCH...

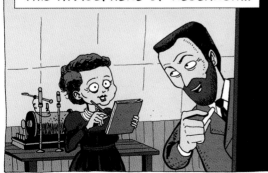

...AND THE *EXCITEMENT* OF ACTUAL PROGRESS WITH THE CONFIDENT HOPE OF STILL BETTER RESULTS.

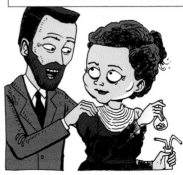

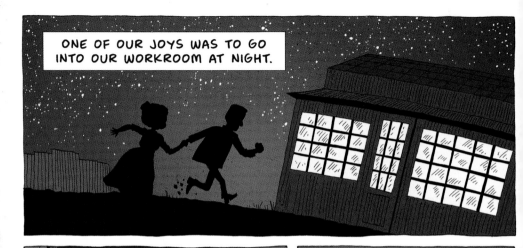

ONE OF OUR JOYS WAS TO GO INTO OUR WORKROOM AT NIGHT.

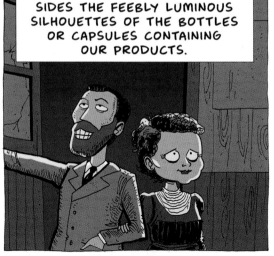

WE THEN PERCEIVED ON ALL SIDES THE FEEBLY LUMINOUS SILHOUETTES OF THE BOTTLES OR CAPSULES CONTAINING OUR PRODUCTS.

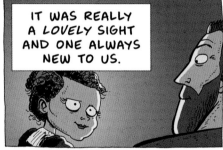

IT WAS REALLY A *LOVELY SIGHT* AND ONE ALWAYS NEW TO US.

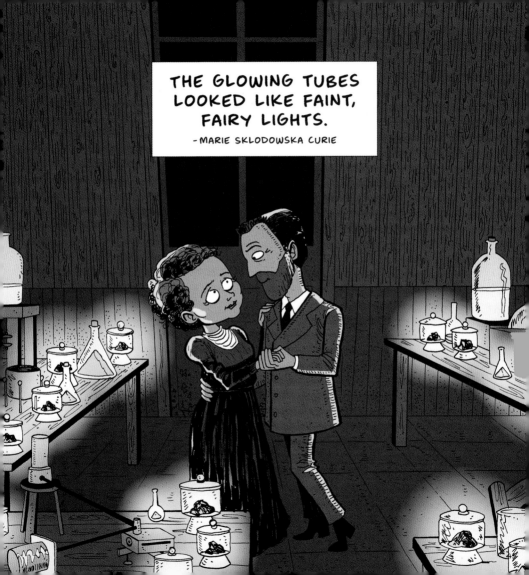

THE GLOWING TUBES LOOKED LIKE FAINT, FAIRY LIGHTS.

- MARIE SKLODOWSKA CURIE

"Humanity, surely, needs practical men who make the best of their work for the sake of their own interests, without forgetting the general interest. But it also needs dreamers, for whom the unselfish following of a purpose is so imperative that it becomes impossible for them to devote much attention to their own material benefit."

—Marie Curie

Marie and Pierre Curie needed a lab. Even though they had discovered two new elements, polonium and radium, the elements still had to be isolated and measured. The University of Paris let them use an old dissecting shed, which was empty because it was deemed unfit to leave cadavers in. That's right, unfit for dead people but fine for a couple of physicists! A visiting scientist described the place as follows: *It was a cross between a stable and a potato cellar, and, if I had not seen the worktable with the chemical apparatus, I would have thought it a practical joke.*

With barely any money or materials, the pair humbly worked away in their cold, wet, and wooden shed, where Marie processed piles of pitchblende. This painstaking task involved boiling the raw ore again and again to separate all the various elements. After four years of arduous work and after processing one metric ton of pitchblende, her sample of radium weighed 0.1 gram.

Of course at the time, the Curies were unaware of the health dangers of working with radioactive materials. Both of them suffered radiation burns and poisoning. Although Marie would eventually succumb to radiation-related illness at age sixty-six, Pierre was tragically killed at forty-six after getting trampled by a horse carriage. Marie was devastated: *"It is impossible for me to express the profoundness and importance of the crisis brought into my life by the loss of the one who had been my closest companion and best friend. Crushed by the blow, I did not feel able to face the future. I could not forget, however, what my husband used sometimes to say, that, even deprived of him, I ought to continue my work."*

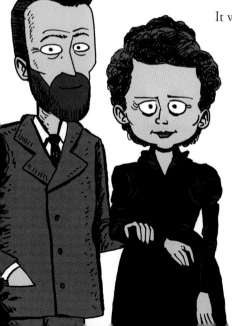

It was those early years spent with Pierre in the abandoned shed where Marie spent her happiest and most creative days. It's clear that the setting for creative work is not important. Einstein got his best ideas in a Swiss patent office; Marie's best years of her career were in a damp, dirty, derelict "potato cellar." You don't need the best laboratory, biggest studio, or the fanciest tools—just a curious mind, a clear purpose, dedication, and love for the work. Having a lover, peer, and companion who shares your vision doesn't hurt either.

CREATIVE PEP TALK #1
Jiddu Krishnamurti

The following comic deals with creativity and fame, based on Krishnamurti's meditation *Anonymous Creativity*.

Jiddu Krishnamurti knew a thing or two about fame. As a thirteen-year-old boy in India, he was discovered by the Theosophical Society and was proclaimed as the next "World Teacher," a Christ-like figure that the society had predicted would lead humanity to peace and understanding. He spent the next nineteen years traveling the world giving lectures and being an obedient Savior-in-waiting.

Then in 1929, the thirty-two-year-old Krishnamurti renounced his destiny. Not interested in fame or being worshipped, he cut ties with the Theosophical Society and spent the next sixty years traveling, writing, and speaking—not tied to any one religion, philosophy, or dogma.

WE WANT TO BE FAMOUS AS A WRITER, AS A POET, AS A PAINTER, AS A POLITICIAN, AS A SINGER, OR WHAT YOU WILL.

WHY?

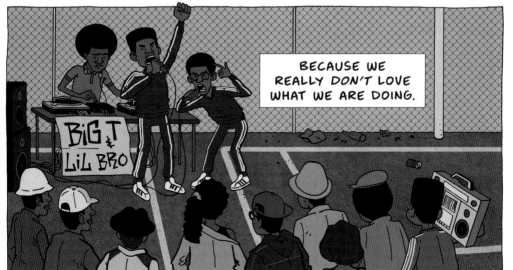

BECAUSE WE REALLY DON'T LOVE WHAT WE ARE DOING.

BiG T & LiL BRO

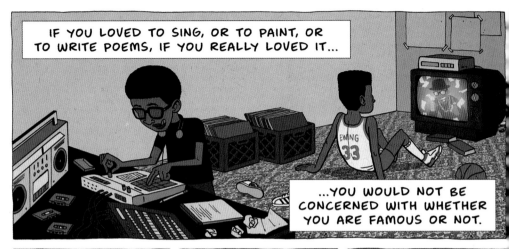

IF YOU LOVED TO SING, OR TO PAINT, OR TO WRITE POEMS, IF YOU REALLY LOVED IT...

...YOU WOULD NOT BE CONCERNED WITH WHETHER YOU ARE FAMOUS OR NOT.

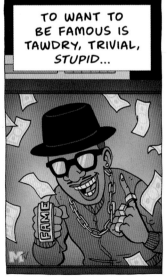

TO WANT TO BE FAMOUS IS TAWDRY, TRIVIAL, STUPID...

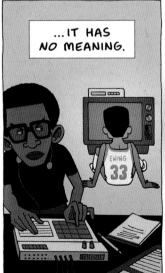

...IT HAS NO MEANING.

BUT BECAUSE WE DON'T LOVE WHAT WE ARE DOING, WE WANT TO ENRICH OURSELVES WITH FAME.

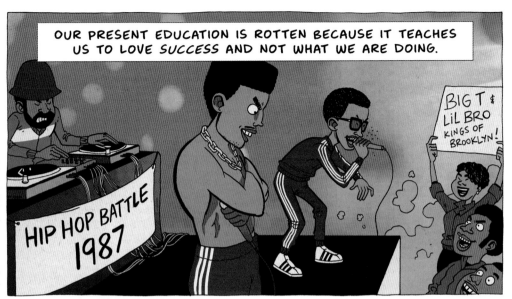

OUR PRESENT EDUCATION IS ROTTEN BECAUSE IT TEACHES US TO LOVE *SUCCESS* AND NOT WHAT WE ARE DOING.

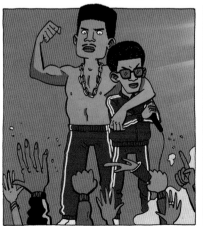

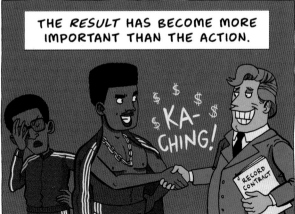

THE *RESULT* HAS BECOME MORE IMPORTANT THAN THE ACTION.

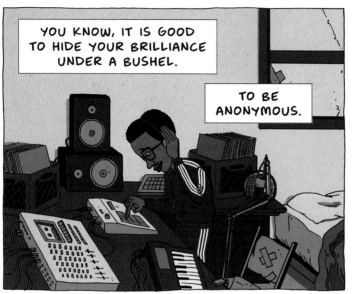

YOU KNOW, IT IS GOOD TO HIDE YOUR BRILLIANCE UNDER A BUSHEL.

TO BE ANONYMOUS.

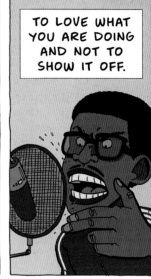

TO LOVE WHAT YOU ARE DOING AND NOT TO SHOW IT OFF.

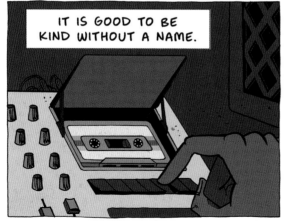

IT IS GOOD TO BE KIND WITHOUT A NAME.

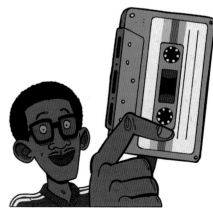

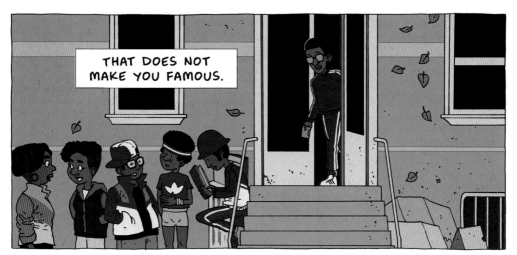

THAT DOES NOT MAKE YOU FAMOUS.

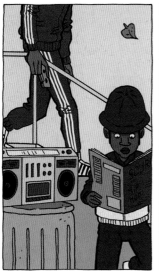

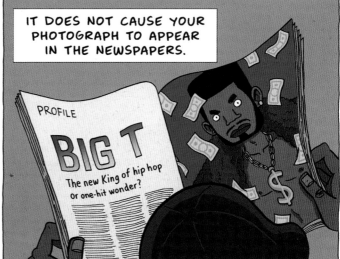

IT DOES NOT CAUSE YOUR PHOTOGRAPH TO APPEAR IN THE NEWSPAPERS.

PROFILE

BIG T

The new King of hip hop or one-hit wonder?

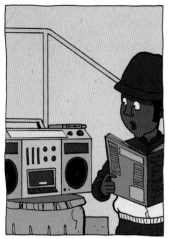
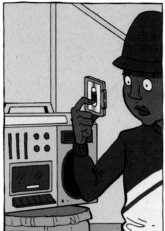

YOU ARE JUST A
CREATIVE HUMAN BEING
LIVING ANONYMOUSLY...

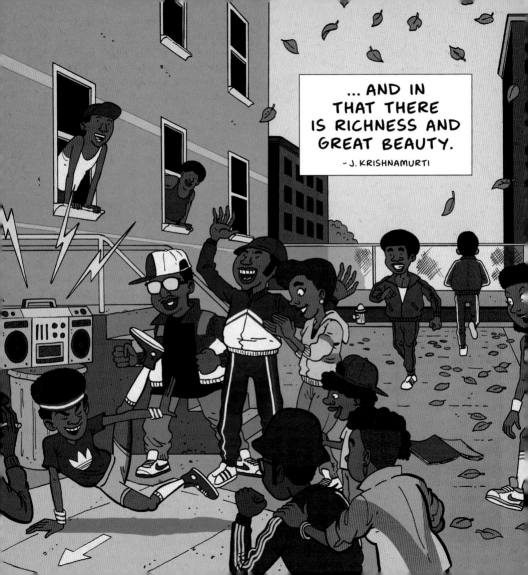

... AND IN THAT THERE IS RICHNESS AND GREAT BEAUTY.

- J. KRISHNAMURTI

LUDWIG VAN BEETHOVEN

Art Has No limits

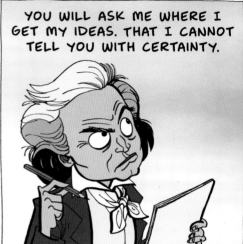

YOU WILL ASK ME WHERE I GET MY IDEAS. THAT I CANNOT TELL YOU WITH CERTAINTY.

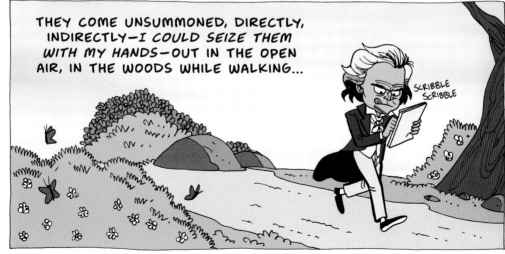

THEY COME UNSUMMONED, DIRECTLY, INDIRECTLY—I COULD SEIZE THEM WITH MY HANDS—OUT IN THE OPEN AIR, IN THE WOODS WHILE WALKING...

SCRIBBLE SCRIBBLE

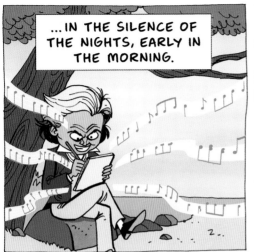

...IN THE SILENCE OF THE NIGHTS, EARLY IN THE MORNING.

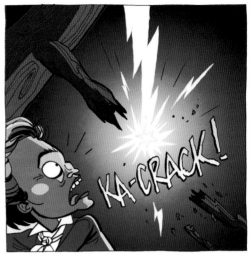

INCITED BY MOODS, WHICH ARE TRANSLATED BY THE POET INTO WORDS...

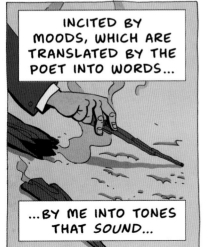

...BY ME INTO TONES THAT *SOUND*...

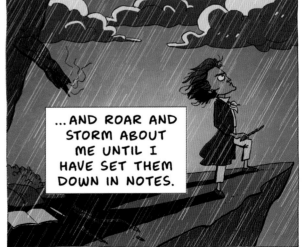

...AND ROAR AND STORM ABOUT ME UNTIL I HAVE SET THEM DOWN IN NOTES.

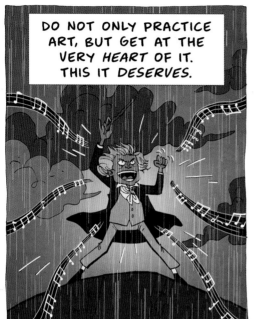

DO NOT ONLY PRACTICE ART, BUT GET AT THE VERY *HEART* OF IT. THIS IT *DESERVES*.

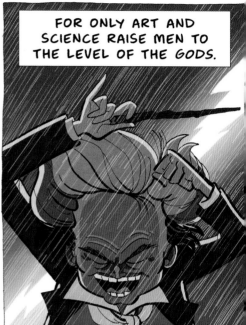

FOR ONLY ART AND SCIENCE RAISE MEN TO THE LEVEL OF THE GODS.

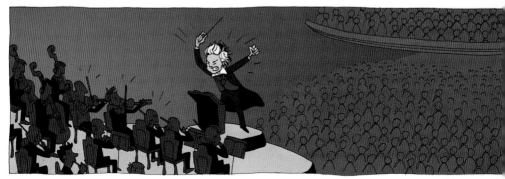

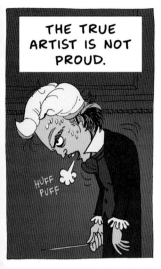

THE TRUE ARTIST IS NOT PROUD.

HUFF PUFF

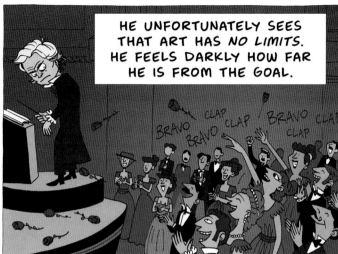

HE UNFORTUNATELY SEES THAT ART HAS *NO LIMITS.* HE FEELS DARKLY HOW FAR HE IS FROM THE GOAL.

BRAVO CLAP CLAP BRAVO CLAP BRAVO CLAP CLAP

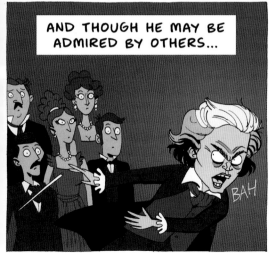

AND THOUGH HE MAY BE ADMIRED BY OTHERS...

BAH

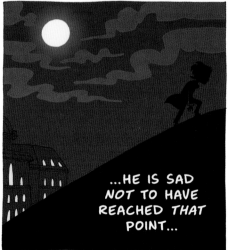

...HE IS SAD *NOT* TO HAVE REACHED *THAT* POINT...

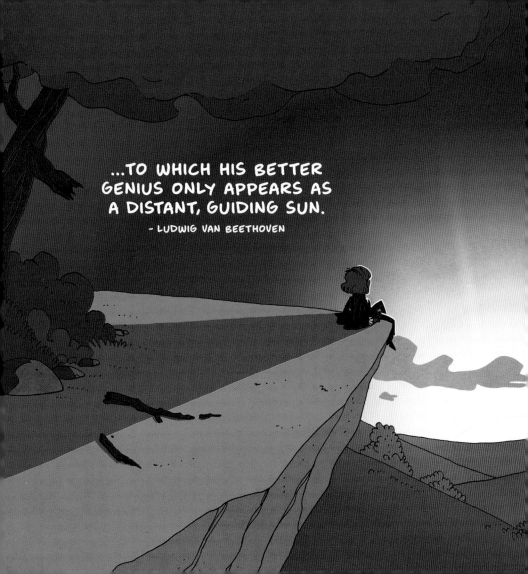

...TO WHICH HIS BETTER GENIUS ONLY APPEARS AS A DISTANT, GUIDING SUN.

- LUDWIG VAN BEETHOVEN

> "I would have put an end to my life—only art it was that withheld me, ah it seemed impossible to leave the world until I had produced all that I felt called upon to produce, and so I endured this wretched existence."
>
> —Ludwig van Beethoven

Can you imagine being one of Vienna's most promising young composers, a piano virtuoso, next in line to the great Haydn and Mozart, only to discover, while in your late twenties, that you were losing your hearing? That's what Ludwig van Beethoven faced. He tried to keep it a secret. What would people think of a deaf composer? Surely his career would be ruined. He avoided social gatherings for two years, closed himself off to the world, and retreated to the countryside to wallow in despair. He contemplated suicide and wrote a farewell letter to his brothers revealing the extent of his suffering. But he never sent it. There was one thing still worth living for: *music*.

Well that was pretty lucky for us because despite his misery, Beethoven went on to write some of the greatest music our unworthy little ears have ever heard. He wasn't going to let a little thing like going deaf stop him. In the ten years after that letter

was written, and with his hearing gradually getting worse and worse, Beethoven composed an opera, six symphonies, four solo concerti, five string quartets, six string sonatas, seven piano sonatas, five sets of piano variations, four overtures, four trios, two sextets, and seventy-two songs. This stage of his output, appropriately known as his "heroic period" included some of his most famous works like the *Fifth Symphony* and *Moonlight Sonata*.

Besides music, Beethoven's other great love was nature. He saw them as intrinsically linked, with his music being a direct expression of nature's beauty. His favorite pastime and source of creativity was the long, daily walks he would take in the countryside. He always carried his notebook with him, ready to write down any music that came to him, often inspired by birdsong. Unlike that show-off Mozart, who could write an original concert on the spot, Beethoven's process was a long and tortuous affair. He would constantly scribble down notes, have to change and revise his pieces, and worked on multiple compositions at the same time over numerous years before he was satisfied.

STEPHEN KING
THE DESK

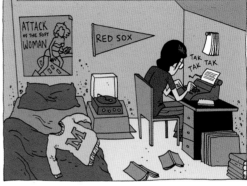

FOR YEARS I DREAMED OF HAVING THE SORT OF MASSIVE OAK SLAB THAT WOULD DOMINATE A ROOM.

ATTACK OF THE SOFT WOMAN

RED SOX

TAK TAK TAK

NO MORE CHILD'S DESK IN A TRAILER LAUNDRY-CLOSET, NO MORE CRAMPED KNEEHOLE IN A RENTED HOUSE.

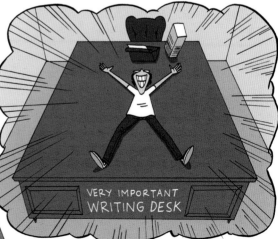

VERY IMPORTANT WRITING DESK

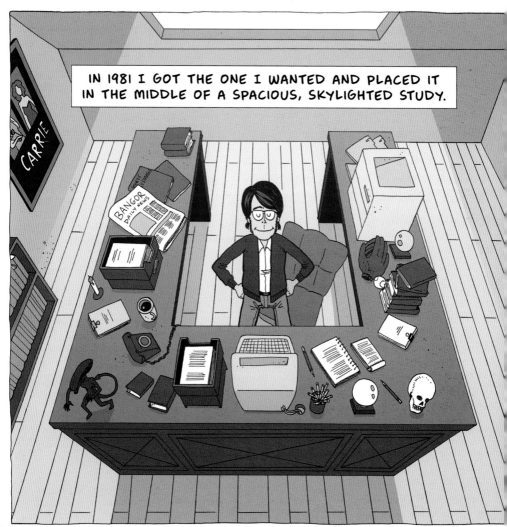

64

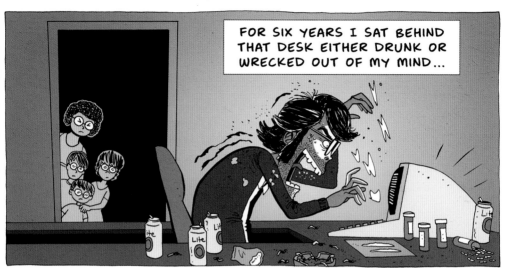

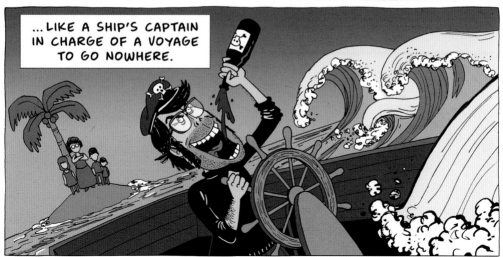

A YEAR OR TWO AFTER I SOBERED UP, I GOT RID OF THAT MONSTROSITY...

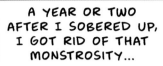

FREE TO GOOD HOME

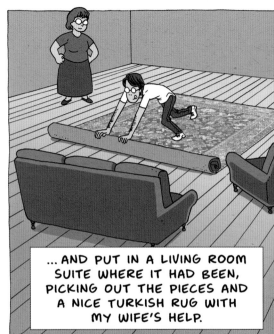

...AND PUT IN A LIVING ROOM SUITE WHERE IT HAD BEEN, PICKING OUT THE PIECES AND A NICE TURKISH RUG WITH MY WIFE'S HELP.

IN THE EARLY NINETIES, BEFORE THEY MOVED ON TO THEIR OWN LIVES, MY KIDS SOMETIMES CAME UP IN THE EVENING TO WATCH A BASKETBALL GAME OR A MOVIE AND EAT PIZZA.

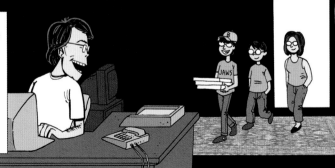

THEY USUALLY LEFT A BOXFUL OF CRUSTS BEHIND WHEN THEY MOVED ON, BUT I DIDN'T CARE.

THEY CAME, THEY SEEMED TO ENJOY BEING WITH ME...

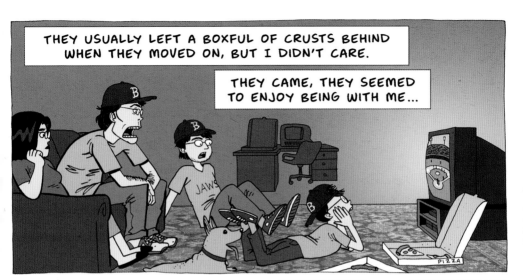

... AND I KNOW I ENJOYED BEING WITH THEM.

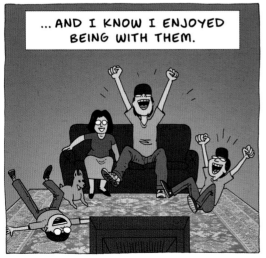

I GOT ANOTHER DESK.

IT'S HANDMADE, BEAUTIFUL, AND HALF THE SIZE OF THE T. REX DESK.

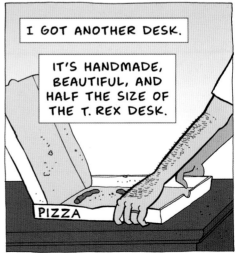

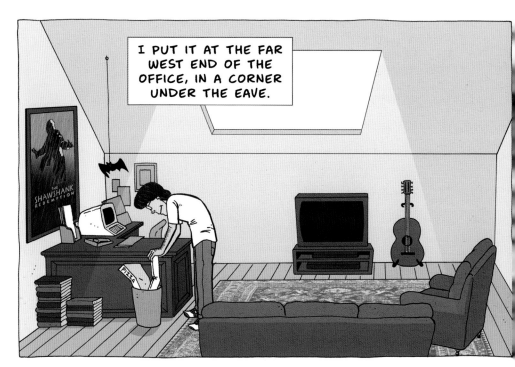

I PUT IT AT THE FAR WEST END OF THE OFFICE, IN A CORNER UNDER THE EAVE.

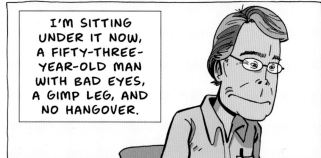

I'M SITTING UNDER IT NOW, A FIFTY-THREE-YEAR-OLD MAN WITH BAD EYES, A GIMP LEG, AND NO HANGOVER.

I'M DOING WHAT I KNOW HOW TO DO, AND AS WELL AS I KNOW HOW TO DO IT. AND NOW I'M GOING TO TELL YOU AS MUCH AS I CAN ABOUT THE JOB.

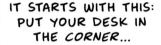

IT STARTS WITH THIS: PUT YOUR DESK IN THE *CORNER*...

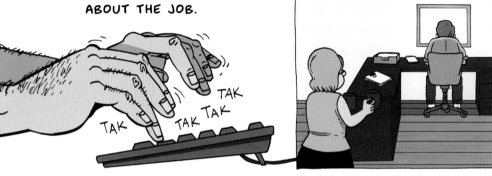

...AND EVERY TIME YOU SIT DOWN THERE TO WRITE, REMIND YOURSELF WHY IT ISN'T IN THE MIDDLE OF THE ROOM.

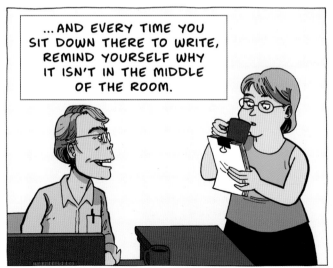

LIFE ISN'T A SUPPORT SYSTEM FOR ART.

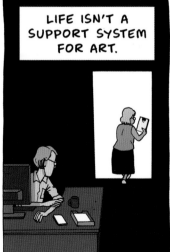

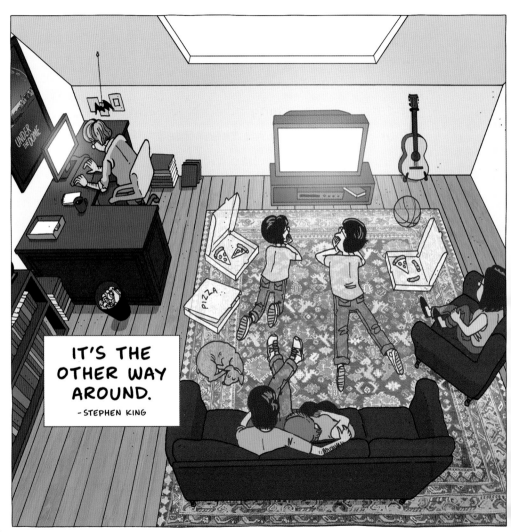

IT'S THE OTHER WAY AROUND.

- STEPHEN KING

> "Good story ideas seem to come quite literally from nowhere, sailing at you right out of the empty sky: two previously unrelated ideas come together and make something new under the sun. Your job isn't to find these ideas but to recognize them when they show up."
>
> —Stephen King

Stephen King has been writing since he was seven years old, when he would copy and rearrange the stories out of his favorite comic books. By his mid-twenties, King was selling the occasional short story to pulp and men's magazines but not nearly enough to make a living. He was working in an industrial laundry, cleaning maggot-infested restaurant linens and hospital sheets, while his wife, Tabitha, also a writer, worked at Dunkin' Donuts. They had two young children, they were living in a trailer, and King was starting to despair that his writing career would never take off.

King chanced upon the idea for his breakthrough novel, *Carrie*, when he recalled working as a high school janitor. When he used to clean the female locker room, he paid special attention to the shower curtains since he knew the boys' lockers didn't have them. He imagined a scene in which a girls' locker room didn't have the

curtains and students were forced to shower in front of each other. What if a girl had her period in the shower but didn't know what it was, and all the other girls laughed and threw tampons at her? How would that girl retaliate? Then King remembered reading an article about telekinesis and how there was evidence that it was prevalent in young girls, especially around the time of their first period. Boom, that's when two unrelated ideas came together to create something new. King wrote three pages of a first draft while working a teaching job. He hated it and threw it in the trash. It was King's wife, Tabitha, who found the pages while emptying the bin and encouraged her husband to finish it. *Carrie* was published in 1974, and King finished off the decade with a string of bestsellers including *'Salem's Lot* and *The Shining.*

By the '80s, King and his family were living in a beautiful house in Bangor, Maine, and King was writing at his dream, massive oak desk. However, he was also an alcoholic and a drug addict. He would write all hours of the day strung out on cocaine and medicate at night with a whole case of sixteen-ounce beers. In 1985 and at risk of losing his family, Tabitha held an intervention and gave King an ultimatum: get help or get out of the house. Thankfully, King managed to get clean and put his family life back together. And thankfully for us, through it all, he never stopped writing.

AKIRA KUROSAWA

The Note taker

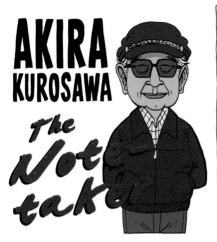

I'VE FORGOTTEN WHO IT WAS THAT SAID CREATION IS MEMORY.

College of Film and Television

FILM FEST 2017

MY OWN EXPERIENCES AND THE VARIOUS THINGS I HAVE READ REMAIN IN MY MEMORY AND BECOME THE BASIS UPON WHICH I CREATE SOMETHING *NEW*.

I COULDN'T DO IT OUT OF NOTHING.

AKIRA KUROSAWA

AKIRA KUROSAWA
Something Like an Autobiography

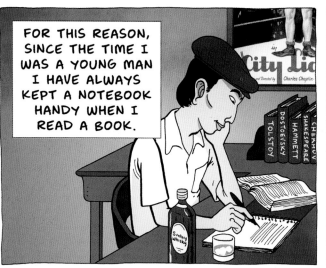

FOR THIS REASON, SINCE THE TIME I WAS A YOUNG MAN I HAVE ALWAYS KEPT A NOTEBOOK HANDY WHEN I READ A BOOK.

I WRITE DOWN MY REACTIONS AND WHAT PARTICULARLY MOVES ME.

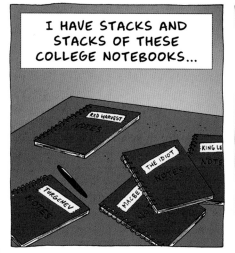

I HAVE STACKS AND STACKS OF THESE COLLEGE NOTEBOOKS...

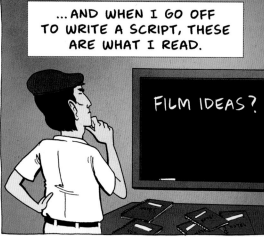

...AND WHEN I GO OFF TO WRITE A SCRIPT, THESE ARE WHAT I READ.

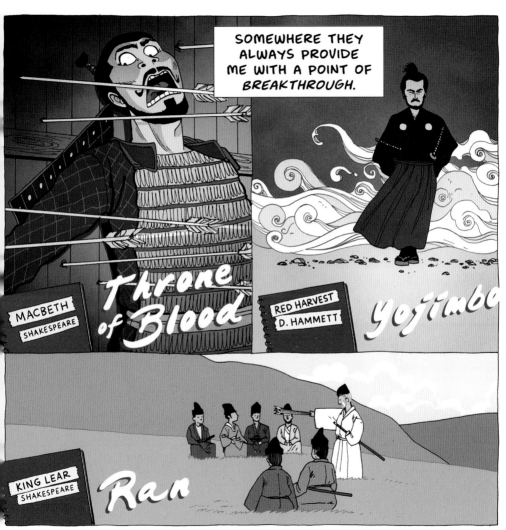

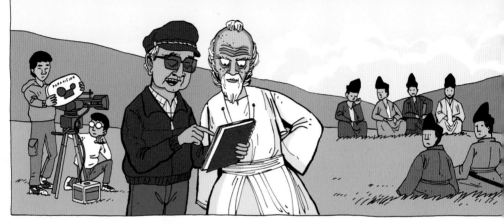

EVEN FOR SINGLE LINES OF DIALOGUE I HAVE TAKEN HINTS FROM THESE NOTEBOOKS.

SO WHAT I WANT TO SAY IS...

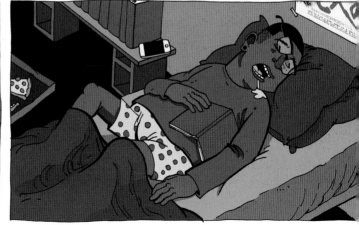

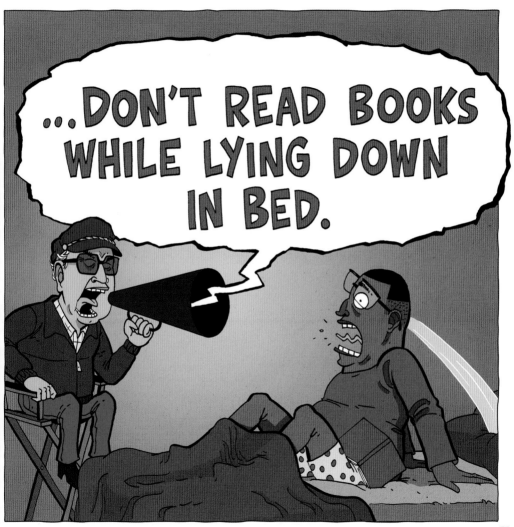

"At some point in the writing of every script, I feel like giving the whole thing up. From my many experiences of writing screenplays, however, I have learned something: If I hold fast in the face of this blankness and despair, adopting the tactic of Bodhidharma, the founder of the Zen sect, who glared at the wall that stood in his way until his legs became useless, a path will open up."

—Akira Kurosawa

A complete dedication to reading and writing were the seeds from which all of the films of the great director, Akira Kurosawa, would grow. He wrote or co-wrote every film he directed. Sometimes he would make a straight adaptation of a work, like of Dostoevsky's *The Idiot* (1951), but mostly he would use another story, novel, or play as inspiration and expand or change it for his own original film.

For instance, *Rashomon* (1950), which launched Kurosawa to international fame and won the Academy Award for Best Foreign-Language Film, was based off two different short stories. *Throne of Blood* (1957) was a Japanese version of Shakespeare's *Macbeth*, and *Ran* (1985) was a retelling of *King Lear*. *Yojimbo* (1961), Kurosawa's

classic tale of a nonchalant samurai playing the two rival gangs against each other, was inspired by the hard-boiled noir of Dashiell Hammett, in particular the novel *Red Harvest*. Kurosawa got the idea for his most famous film, *Seven Samurai* (1954), after reading a story about a group of samurai defending a farming village.

Now Kurosawa didn't just steal other people's ideas. He added his own experiences, his own ideas, and his own culture to make them his own. It's easy to look at your favorite books, films, or TV shows and think to yourself, "How do they come up with that?" or "There's no way I could create something out of thin air like they did," but then you discover that it's OK to recycle and reinterpret old ideas.

Suddenly, creating your own art doesn't seem as daunting when you realize even a master like Kurosawa needed a little help to get his films off the ground.

Pyotr Ilyich
Tchaikovsky

In
the
MOOD
for
WORK

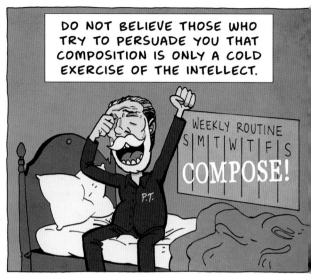

DO NOT BELIEVE THOSE WHO TRY TO PERSUADE YOU THAT COMPOSITION IS ONLY A COLD EXERCISE OF THE INTELLECT.

WEEKLY ROUTINE
S M T W T F S
COMPOSE!

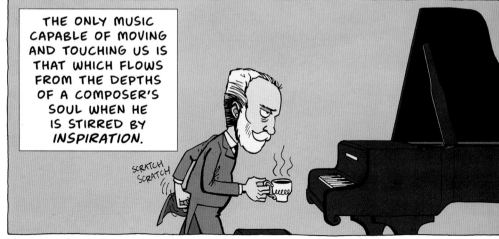

THE ONLY MUSIC CAPABLE OF MOVING AND TOUCHING US IS THAT WHICH FLOWS FROM THE DEPTHS OF A COMPOSER'S SOUL WHEN HE IS STIRRED BY *INSPIRATION.*

SCRATCH SCRATCH

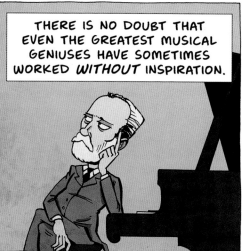

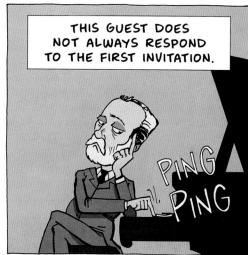

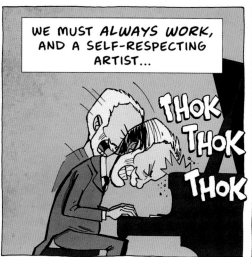

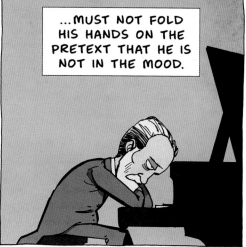

81

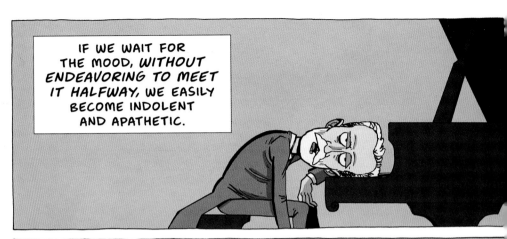

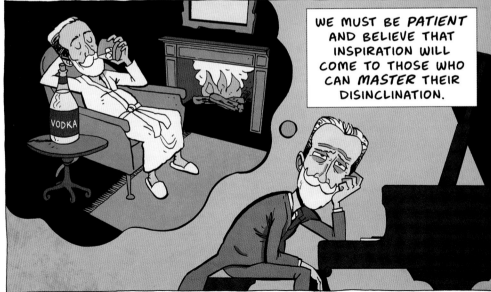

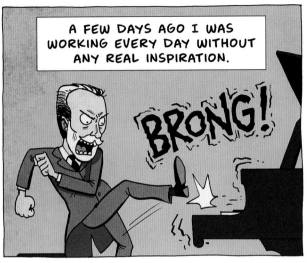

A FEW DAYS AGO I WAS WORKING EVERY DAY WITHOUT ANY REAL INSPIRATION.

BRONG!

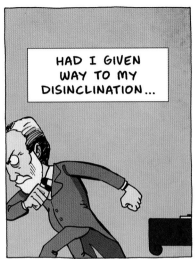

HAD I GIVEN WAY TO MY DISINCLINATION...

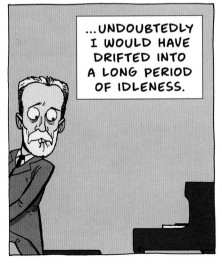

...UNDOUBTEDLY I WOULD HAVE DRIFTED INTO A LONG PERIOD OF IDLENESS.

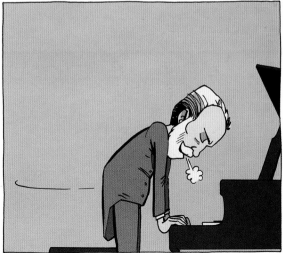

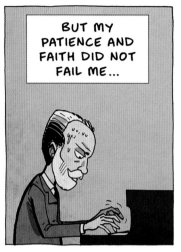

BUT MY PATIENCE AND FAITH DID NOT FAIL ME...

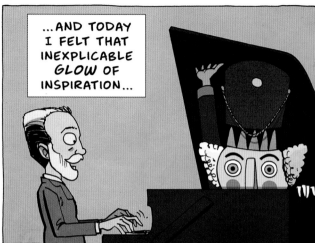

...AND TODAY I FELT THAT INEXPLICABLE *GLOW* OF INSPIRATION...

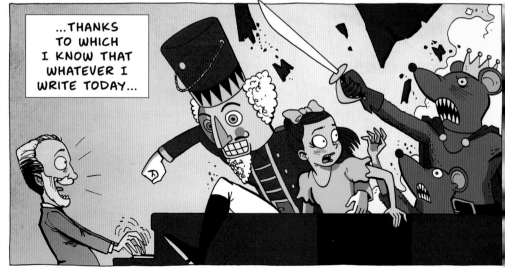

...THANKS TO WHICH I KNOW THAT WHATEVER I WRITE TODAY...

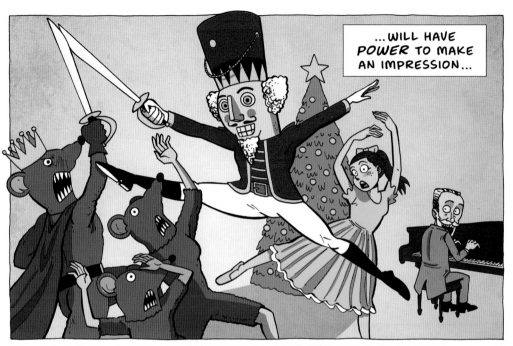

...WILL HAVE **POWER** TO MAKE AN IMPRESSION...

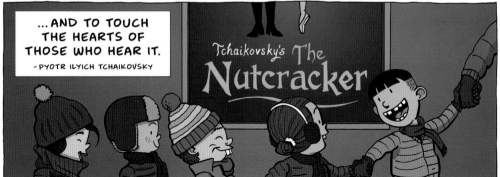

...AND TO TOUCH THE HEARTS OF THOSE WHO HEAR IT.

- PYOTR ILYICH TCHAIKOVSKY

Tchaikovsky's The **Nutcracker**

> "Undoubtedly I should have gone mad but for music. Music is indeed the most beautiful of all heaven's gifts to humanity wandering in the darkness. Alone it calms, enlightens, and stills our souls. It is not the straw to which the drowning man clings; but a true friend, refuge, and comforter, for whose sake life is worth living."
>
> —Pyotr Ilyich Tchaikovsky

Most freelancers take on a job that they're not that excited about—I know I have. The brief doesn't excite them, they can't get creatively enthusiastic about it, or sometimes the people involved are a pain to deal with. Whatever it is, they wish they never said "yes" to it in the first place. The great Russian composer Pyotr Ilyich Tchaikovsky felt that way about *The Nutcracker*. The Russian Imperial Theater was coming fresh off the success of Tchaikovsky's previous ballet, *The Sleeping Beauty*, and commissioned him to compose the music for a ballet based on the fairy tale *The Nutcracker and the Mouse King*.

Tchaikovsky was not thrilled about the job. Not only was he busy with other work and had an upcoming tour of America to worry about, but he also didn't like the

story at all. But one does not turn down an imperial commission backed by the tsar, so, being a "self-respecting artist," Tchaikovsky gritted his teeth and got to work. The ballet was a struggle from start to finish. As he wrote in a letter, *"Today, even more than yesterday, I feel the absolute impossibility of depicting in music the 'Sugar Plum Fairy.'"* When he finally did finish it, Tchaikovsky wrote, *"This ballet is far weaker than The Sleeping Beauty—no doubt about it."* Of course, today *The Nutcracker* is the most successful ballet of all time, generates the bulk of profits for ballet companies around the world, and is the gateway to classical music for children of all ages.

Tchaikovsky was near the end of his career by the time he composed *The Nutcracker* and had conditioned himself to work day in and day out, knowing that inspiration doesn't fall like manna from heaven every day. And that's what separates the pros from the hobbyists, the ability to create when you don't feel like creating. The ability to "master their disinclination."

CREATIVE PEP TALK #2
Brené Brown

Dr. Brené Brown is a bestselling author and research professor at the University of Houston. She has spent her career researching courage, vulnerability, shame, and creativity.

The following words are taken from her book, *The Gifts of Imperfection.*

THE ETERNAL STRUGGLE

INNER DEMON **VS** CREATIVE SPIRIT

CHAMPION **CHALLENGER**

VENUE YOUR SOUL ● DATE EVERY DAY OF YOUR LIFE ● TIME NOW!

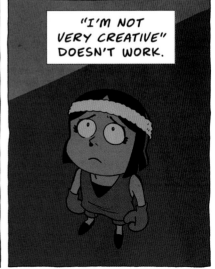

"I'M NOT VERY CREATIVE" DOESN'T WORK.

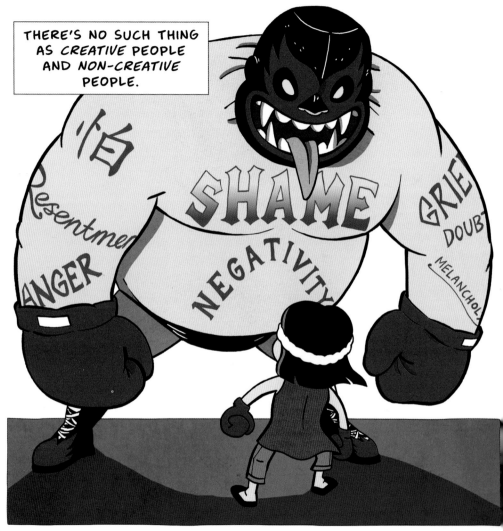

THERE ARE ONLY PEOPLE WHO USE THEIR CREATIVITY...

DING DING!

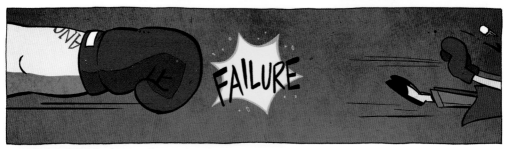

FAILURE

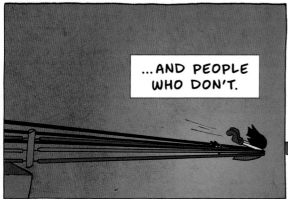

...AND PEOPLE WHO DON'T.

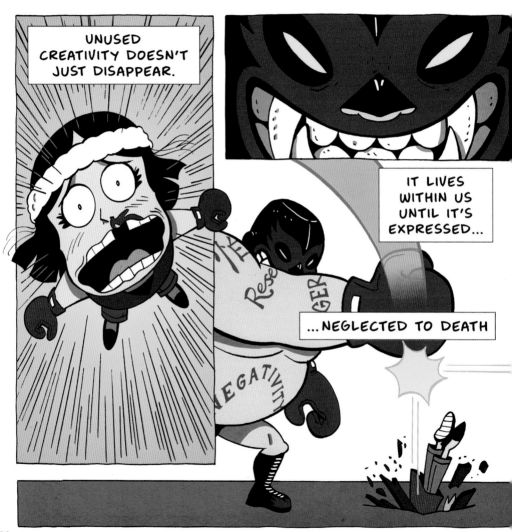

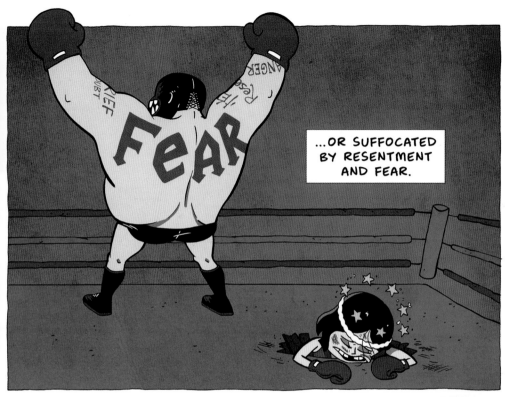

...OR SUFFOCATED BY RESENTMENT AND FEAR.

DING DING!

THE ONLY UNIQUE CONTRIBUTION THAT WE WILL EVER MAKE IN THIS WORLD WILL BE BORN OF OUR *CREATIVITY.*

DING DING!

FIGHT FIGHT FIGHT

IF WE WANT TO MAKE MEANING...

...WE NEED TO MAKE...

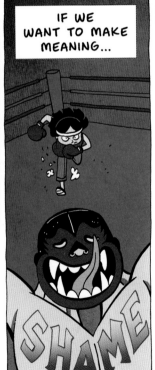

SHAME

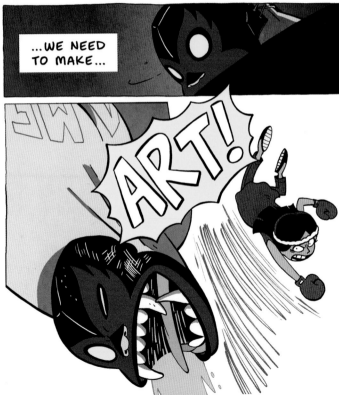

ART!

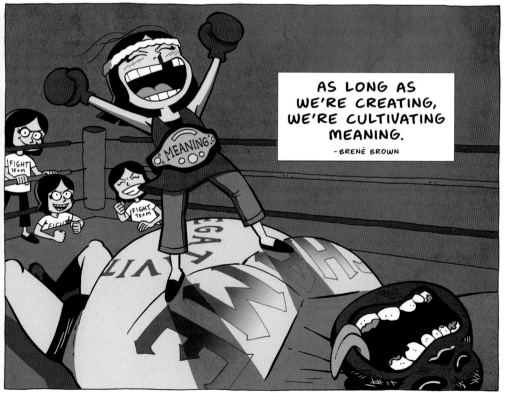

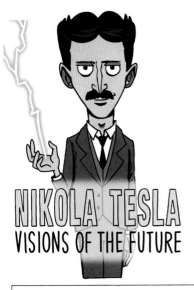

NIKOLA TESLA
VISIONS OF THE FUTURE

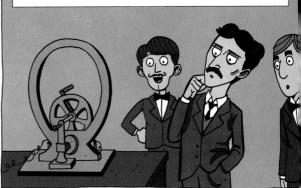

IT WAS IN THE SECOND YEAR OF MY STUDIES THAT WE RECEIVED A GRAMME DYNAMO FROM PARIS. IT WAS CONNECTED UP AND VARIOUS EFFECTS OF THE CURRENTS WERE SHOWN.

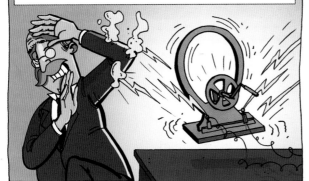

WHILE PROFESSOR POESCHL WAS MAKING DEMONSTRATIONS, RUNNING THE MACHINE AS A MOTOR, THE BRUSHES GAVE TROUBLE, SPARKING BADLY...

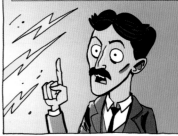

...I OBSERVED THAT IT MIGHT BE POSSIBLE TO OPERATE A MOTOR WITHOUT THESE APPLIANCES. BUT HE DECLARED THAT IT COULD NOT BE DONE.

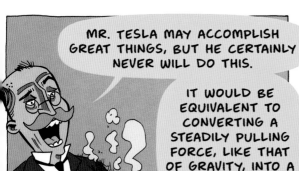

MR. TESLA MAY ACCOMPLISH GREAT THINGS, BUT HE CERTAINLY NEVER WILL DO THIS.

IT WOULD BE EQUIVALENT TO CONVERTING A STEADILY PULLING FORCE, LIKE THAT OF GRAVITY, INTO A ROTARY EFFORT.

IT IS A PERPETUAL MOTION SCHEME, AN *IMPOSSIBLE* IDEA.

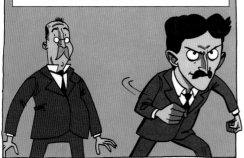

FOR A TIME I WAVERED, IMPRESSED BY THE PROFESSOR'S AUTHORITY, BUT SOON BECAME CONVINCED I WAS RIGHT AND UNDERTOOK THE TASK WITH ALL THE FIRE AND BOUNDLESS CONFIDENCE OF YOUTH.

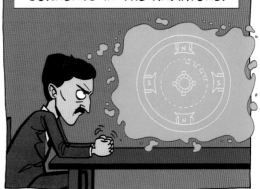

I STARTED BY FIRST PICTURING IN MY MIND A DIRECT-CURRENT MACHINE, RUNNING IT AND FOLLOWING THE CHANGING FLOW OF THE CURRENTS IN THE ARMATURE.

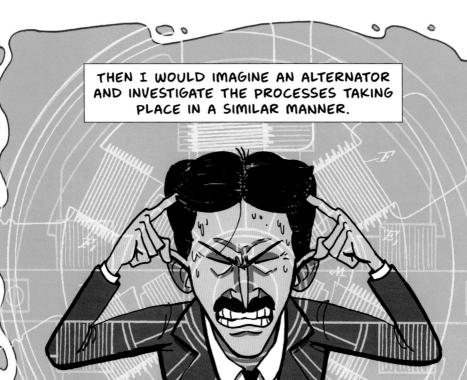

ALL MY REMAINING TERM IN GRATZ WAS PASSED IN INTENSE BUT FRUITLESS EFFORTS OF THIS KIND...

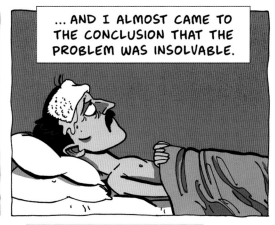

... AND I ALMOST CAME TO THE CONCLUSION THAT THE PROBLEM WAS INSOLVABLE.

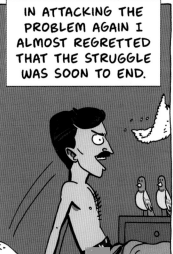

IN ATTACKING THE PROBLEM AGAIN I ALMOST REGRETTED THAT THE STRUGGLE WAS SOON TO END.

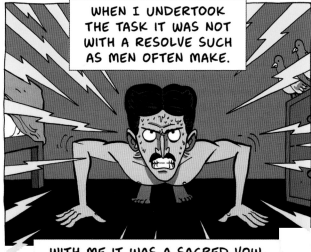

WHEN I UNDERTOOK THE TASK IT WAS NOT WITH A RESOLVE SUCH AS MEN OFTEN MAKE.

WITH ME IT WAS A SACRED VOW, A QUESTION OF *LIFE* AND *DEATH*.

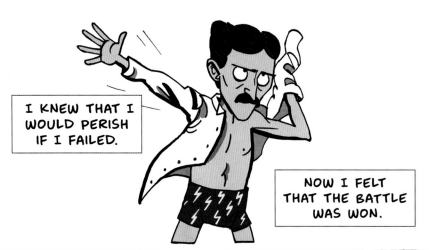

I KNEW THAT I WOULD PERISH IF I FAILED.

NOW I FELT THAT THE BATTLE WAS WON.

BACK IN THE DEEP RECESSES OF THE BRAIN WAS THE SOLUTION, BUT I COULD NOT YET GIVE IT OUTWARD EXPRESSION.

ONE AFTERNOON, WHICH IS EVER PRESENT IN MY RECOLLECTION, I WAS ENJOYING A WALK WITH MY FRIEND IN THE CITY PARK AND RECITING POETRY.

ONE OF THESE WAS GOETHE'S "FAUST."

THE SUN WAS JUST SETTING AND REMINDED ME OF THE GLORIOUS PASSAGE...

The glow retreats, done is the day of toil. It yonder hastes, new fields of life exploring. Ah, that no wing can lift me from the soil Upon its track to follow, follow soaring!

A glorious dream! Though now the glories fade. *Alas!* the wings that lift the mind no aid Of wings to lift the body can bequeath me.

AS I UTTERED THESE INSPIRING WORDS THE IDEA CAME LIKE A FLASH OF LIGHTNING, AND IN AN INSTANT THE TRUTH WAS REVEALED.

I DREW WITH A STICK ON THE SAND, AND MY COMPANION UNDERSTOOD THEM PERFECTLY.

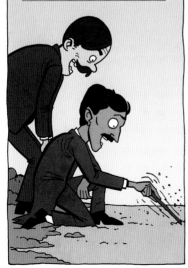

THE IMAGES I SAW WERE WONDERFULLY SHARP AND CLEAR AND HAD THE SOLIDITY OF METAL AND STONE.

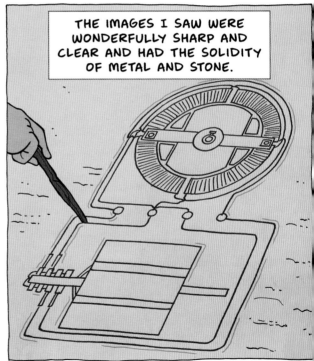

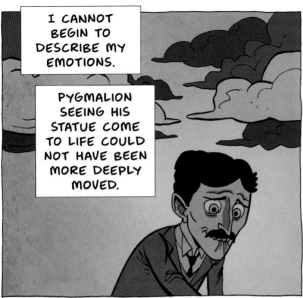

I CANNOT BEGIN TO DESCRIBE MY EMOTIONS.

PYGMALION SEEING HIS STATUE COME TO LIFE COULD NOT HAVE BEEN MORE DEEPLY MOVED.

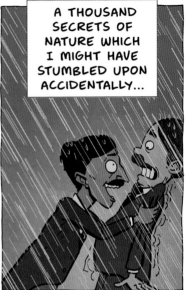

A THOUSAND SECRETS OF NATURE WHICH I MIGHT HAVE STUMBLED UPON ACCIDENTALLY...

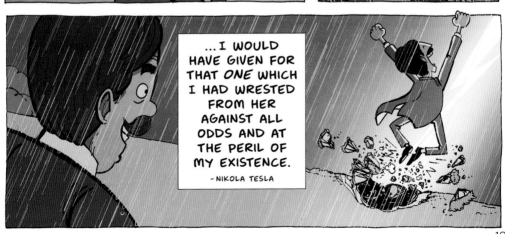

...I WOULD HAVE GIVEN FOR THAT *ONE* WHICH I HAD WRESTED FROM HER AGAINST ALL ODDS AND AT THE PERIL OF MY EXISTENCE.

- NIKOLA TESLA

> "When natural inclination develops into a passionate desire, one advances toward his goal in seven-league boots."
>
> —Nikola Tesla

The one secret that Nikola Tesla wrested from nature on that fateful day in a Budapest park was the design for his most famous and important invention: the alternating-current induction motor. Before Tesla's breakthrough, all electricity and motors used a direct current system, like the Gramme dynamo Professor Poeschl was demonstrating at Tesla's polytechnic school in Gratz. Direct current motors were prone to wear and tear and sparking due to the number of moving parts brushing up against each other. Much to the disgust of his professor, Tesla thought he could do away with the inefficiencies and sparking (in particular caused by a part known as a commutator). The genius of Tesla's AC motor was its simplicity. There was no need for a commutator because the rotor moved due to a rotating electric field. This meant that the motor was more efficient, reliable, quieter, and cheaper. In the "War of the Currents" between Thomas Edison's DC power and the AC system, Tesla's alternating current prevailed and today is the basis of all modern power generation and distribution. Suck it, Professor Poeschl.

Tesla's creative process was quite different to other engineers and scientists. He didn't write things down, sketch out ideas, or refine on the page. Instead he relied solely on *visualization*—creating, developing, fixing, and testing all his inventions completely in his mind. Einstein used thought experiments to generate the initial spark of an idea. But once he got that first inspiration, he still had to figure out all the complex physics and equations down on paper. Tesla didn't waste his time like that:

"My method is different. I do not rush into actual work. When I get an idea, I start at once building it up in my imagination. I change the construction, make improvements, and operate the device in my mind. It is absolutely immaterial to me whether I run my turbine in thought or test it in my shop. . . . In twenty years there has not been a single exception."

Yes, we're dealing with a super genius here, so granted, Tesla's method might be out of reach for mere mortals like the rest of us. I'm sure his photographic memory helped a bit too. It's not fair that someone can casually recite Goethe at the same time as inventing a world-changing motor.

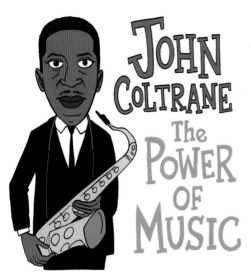

JOHN COLTRANE
The POWER OF MUSIC

MY GOAL IS TO LIVE THE TRULY RELIGIOUS LIFE AND EXPRESS IT IN MY MUSIC.

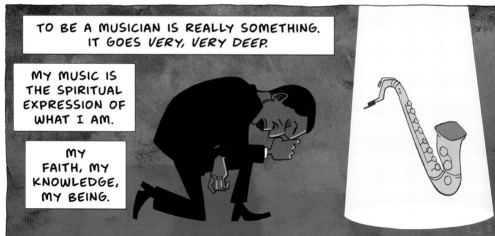

BIRDLAND

TONIGHT! JOHN COLTRANE QUARTET

JAZZ BEBOP

TO BE A MUSICIAN IS REALLY SOMETHING. IT GOES *VERY, VERY DEEP.*

MY MUSIC IS THE SPIRITUAL EXPRESSION OF WHAT I AM.

MY FAITH, MY KNOWLEDGE, MY BEING.

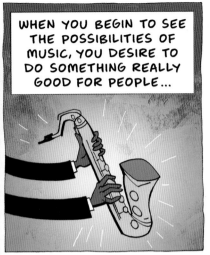

WHEN YOU BEGIN TO SEE THE POSSIBILITIES OF MUSIC, YOU DESIRE TO DO SOMETHING REALLY GOOD FOR PEOPLE...

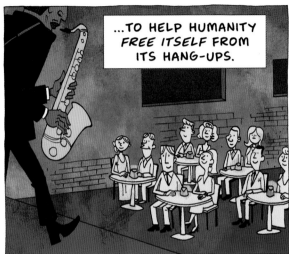

...TO HELP HUMANITY FREE ITSELF FROM ITS HANG-UPS.

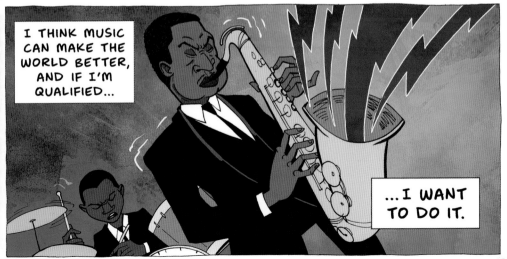

I THINK MUSIC CAN MAKE THE WORLD BETTER, AND IF I'M QUALIFIED...

...I WANT TO DO IT.

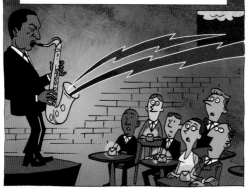

I WOULD LIKE TO DISCOVER A METHOD SO THAT IF I WANT IT TO RAIN...

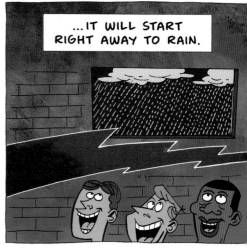

...IT WILL START RIGHT AWAY TO RAIN.

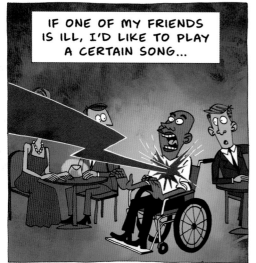

IF ONE OF MY FRIENDS IS ILL, I'D LIKE TO PLAY A CERTAIN SONG...

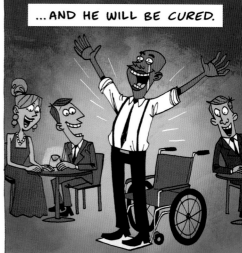

...AND HE WILL BE CURED.

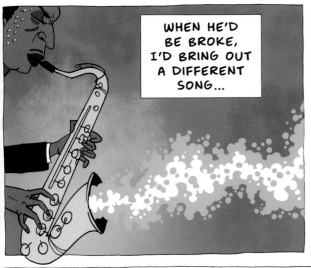

WHEN HE'D BE BROKE, I'D BRING OUT A DIFFERENT SONG...

...AND IMMEDIATELY HE'D RECEIVE ALL THE MONEY HE NEEDED.

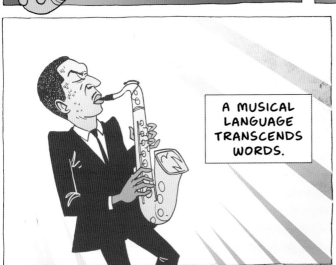

A MUSICAL LANGUAGE TRANSCENDS WORDS.

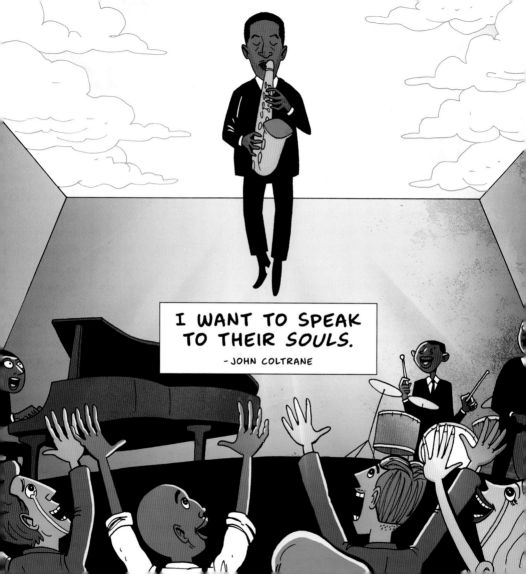

"Once you become aware of this force for unity in life, you can't ever forget it. It becomes part of everything you do . . . My goal in meditating on this through music . . . is to uplift people, as much as I can. To inspire them to realize more and more of their capacities for living meaningful lives. Because there certainly is meaning to life."

—John Coltrane

John Coltrane was already one of the most in-demand saxophonists in jazz when he was kicked out of Miles Davis's band in 1957 due to his heroin addiction. By then he had played with all the greats—Charlie Parker, Dizzy Gillespie, Thelonious Monk, Miles Davis—and was on his way to becoming one of the greats himself when his drug and alcohol problems caught up with him. Coltrane was saved by a spiritual awakening. His religiousness helped him kick his addiction and gave him a new purpose in life and music.

Once Coltrane combined his masterful skill (he was known to obsessively practice for up to twelve hours a day and his wife would often find him asleep with the sax

still in his mouth) with his spiritual purpose, he became a force of musical nature. Coltrane's new direction culminated in his best-known album, *A Love Supreme*, released in 1964.

In *A Love Supreme* Coltrane offers up his gratitude to a higher power through music, and the album is considered not only one of the most influential jazz albums ever, but one of the most influential albums ever—regardless of genre. Coltrane didn't believe in one religion. Although he was raised in the Christian faith, Coltrane intensely studied all the world religions and was deeply influenced by Islam, Hinduism, and Zen Buddhism. Coltrane's live performances became musical sermons as he searched for a way to tap into the beauty of nature and the divine through the power of his horn.

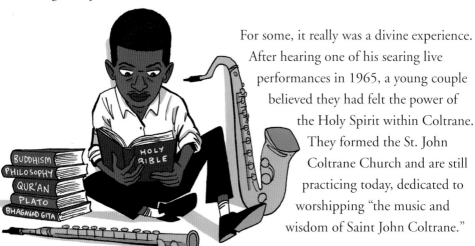

For some, it really was a divine experience. After hearing one of his searing live performances in 1965, a young couple believed they had felt the power of the Holy Spirit within Coltrane. They formed the St. John Coltrane Church and are still practicing today, dedicated to worshipping "the music and wisdom of Saint John Coltrane."

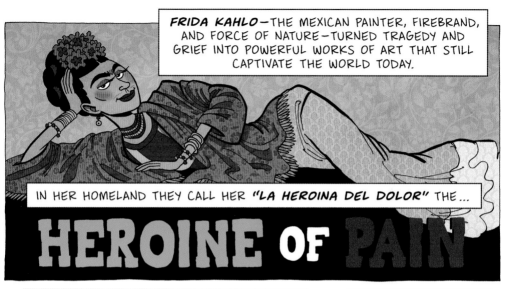

FRIDA KAHLO—THE MEXICAN PAINTER, FIREBRAND, AND FORCE OF NATURE—TURNED TRAGEDY AND GRIEF INTO POWERFUL WORKS OF ART THAT STILL CAPTIVATE THE WORLD TODAY.

IN HER HOMELAND THEY CALL HER **"LA HEROINA DEL DOLOR"** THE...

HEROINE OF PAIN

AT AGE SIX **FRIDA CONTRACTED POLIO**, WHICH MADE HER RIGHT LEG WITHERED AND FRAIL. SHE WALKED WITH A LIMP AND WAS TEASED AT SCHOOL.

¡PATA DE PALO!*

*PEG LEG

OVER TIME HER LIMP SEVERELY DAMAGED HER SPINE AND PELVIS WHICH CAUSED FRIDA PROBLEMS FOR THE REST OF HER LIFE.

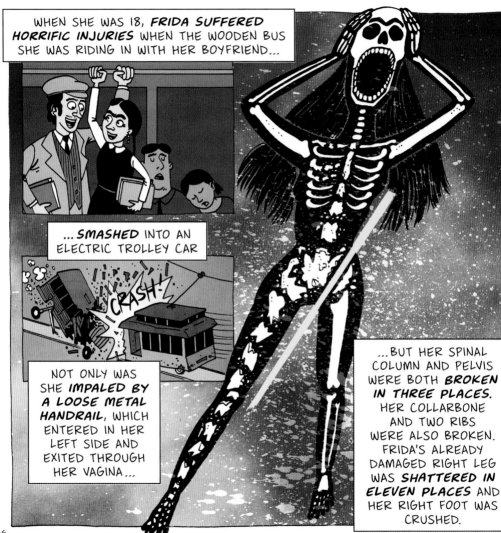

WHEN SHE WAS 18, **FRIDA SUFFERED HORRIFIC INJURIES** WHEN THE WOODEN BUS SHE WAS RIDING IN WITH HER BOYFRIEND...

...SMASHED INTO AN ELECTRIC TROLLEY CAR

CRASH

NOT ONLY WAS SHE **IMPALED BY A LOOSE METAL HANDRAIL**, WHICH ENTERED IN HER LEFT SIDE AND EXITED THROUGH HER VAGINA...

...BUT HER SPINAL COLUMN AND PELVIS WERE BOTH **BROKEN IN THREE PLACES.** HER COLLARBONE AND TWO RIBS WERE ALSO BROKEN. FRIDA'S ALREADY DAMAGED RIGHT LEG WAS **SHATTERED IN ELEVEN PLACES** AND HER RIGHT FOOT WAS CRUSHED.

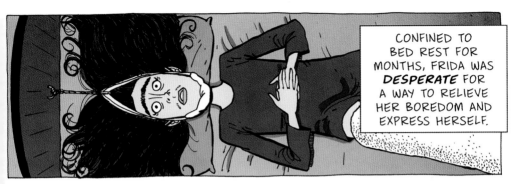

CONFINED TO BED REST FOR MONTHS, FRIDA WAS **DESPERATE** FOR A WAY TO RELIEVE HER BOREDOM AND EXPRESS HERSELF.

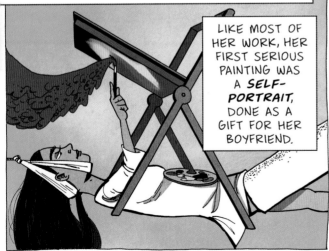

SHE FOUND THE PERFECT OUTLET THROUGH PAINTING. BORROWING HER FATHER'S PAINTS AND WITH THE HELP OF A SPECIAL EASEL MADE JUST FOR HER, FRIDA DISCOVERED A PASSION SHE NEVER KNEW SHE HAD.

LIKE MOST OF HER WORK, HER FIRST SERIOUS PAINTING WAS A **SELF-PORTRAIT**, DONE AS A GIFT FOR HER BOYFRIEND.

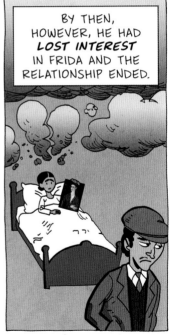

BY THEN, HOWEVER, HE HAD **LOST INTEREST** IN FRIDA AND THE RELATIONSHIP ENDED.

BUT FRIDA'S RELATIONSHIP WITH PAINTING **HAD JUST BEGUN.** SHE ABANDONED HER PLANS TO GO TO MEDICAL SCHOOL AND BECAME SERIOUS ABOUT ART.

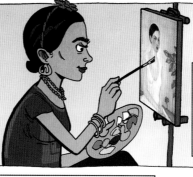

THROUGH THE TRAGEDY OF HER ACCIDENT SHE HAD **FOUND HER CALLING.**

SOON AFTER, FRIDA FOUND THE OTHER OBSESSION THAT WOULD DOMINATE HER LIFE: **DIEGO RIVERA.**

DIEGO WAS A WORLD-RENOWNED ARTIST AND THE 42-YEAR-OLD, 300-POUND MURALIST **MARRIED** THE 22-YEAR-OLD, 98-POUND FRIDA KAHLO IN 1929.

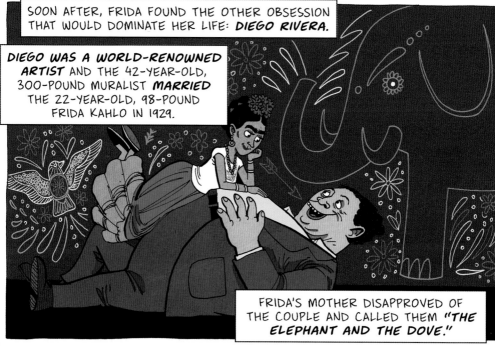

FRIDA'S MOTHER DISAPPROVED OF THE COUPLE AND CALLED THEM **"THE ELEPHANT AND THE DOVE."**

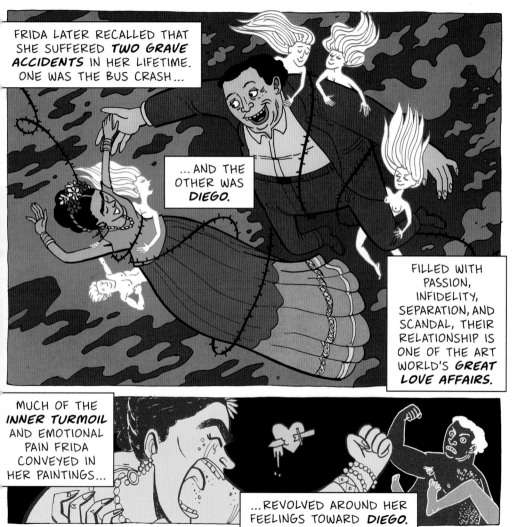

119

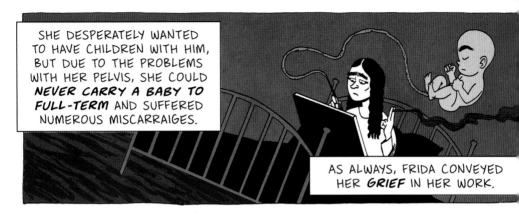

SHE DESPERATELY WANTED TO HAVE CHILDREN WITH HIM, BUT DUE TO THE PROBLEMS WITH HER PELVIS, SHE COULD **NEVER CARRY A BABY TO FULL-TERM** AND SUFFERED NUMEROUS MISCARRAIGES.

AS ALWAYS, FRIDA CONVEYED HER **GRIEF** IN HER WORK.

DESPITE HER CHRONIC HEALTH PROBLEMS, FRIDA WAS FUN, FEISTY, AND IRRESISTIBLE TO NEARLY EVERYONE SHE MET. BOTH WITTY AND INTELLECTUAL, **SHE ENCHANTED SOME OF THE GREATEST THINKERS AND ARTISTS OF HER TIME.**

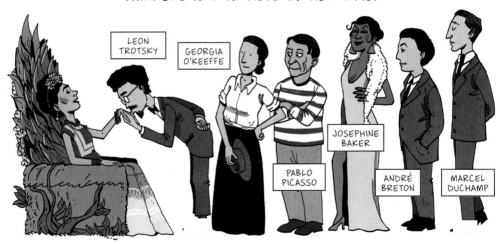

BUT AS SHE GREW OLDER, FRIDA'S **HEALTH PROBLEMS WORSENED.** AN ARRAY OF MEDICAL CORSETS FAILED TO HELP AND SHE WAS FORCED TO UNDERGO RADICAL SURGERY ON HER SPINE AND LEG.

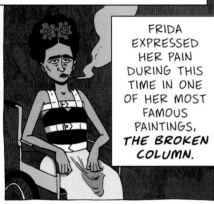

FRIDA EXPRESSED HER PAIN DURING THIS TIME IN ONE OF HER MOST FAMOUS PAINTINGS, **THE BROKEN COLUMN.**

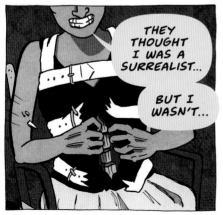

THEY THOUGHT I WAS A SURREALIST...

BUT I WASN'T...

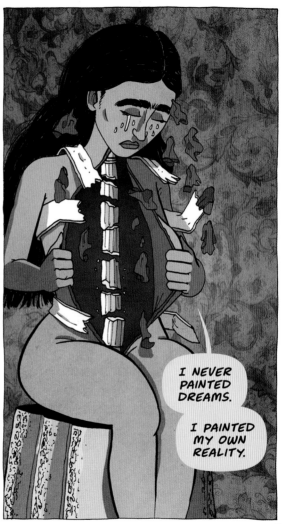

I NEVER PAINTED DREAMS.

I PAINTED MY OWN REALITY.

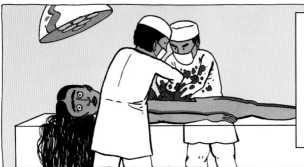

IN TOTAL, FRIDA HAD **OVER 30 SURGERIES** THROUGHOUT HER LIFE, INCLUDING SEVEN JUST ON HER SPINE. SHE EVEN HAD TO **UNDERGO A SECOND SPINAL FUSION** AFTER IT WAS DISCOVERED THAT THE WRONG VERTEBRAE WERE FUSED THE FIRST TIME.

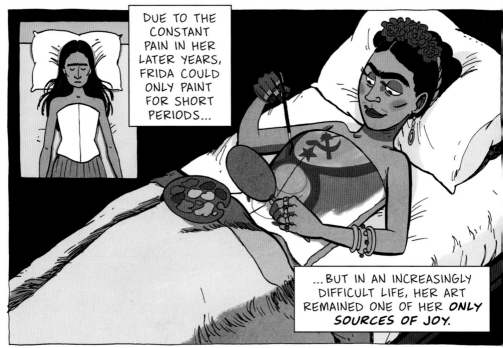

DUE TO THE CONSTANT PAIN IN HER LATER YEARS, FRIDA COULD ONLY PAINT FOR SHORT PERIODS...

...BUT IN AN INCREASINGLY DIFFICULT LIFE, HER ART REMAINED ONE OF HER **ONLY SOURCES OF JOY.**

DESPITE HAVING PREVIOUS EXHIBITIONS IN NEW YORK AND PARIS, FRIDA HAD NEVER HAD ONE IN MEXICO. SO IN 1953, WITH HER HEALTH FAILING, SHE WAS FINALLY GIVEN HER *FIRST SOLO EXHIBITION IN HER HOMELAND.*

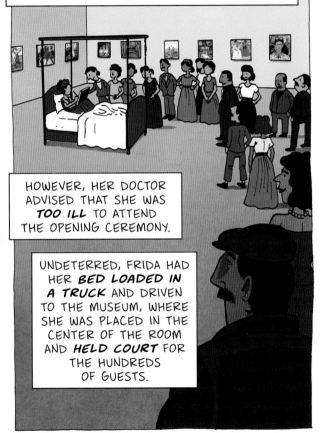

HOWEVER, HER DOCTOR ADVISED THAT SHE WAS *TOO ILL* TO ATTEND THE OPENING CEREMONY.

UNDETERRED, FRIDA HAD HER *BED LOADED IN A TRUCK* AND DRIVEN TO THE MUSEUM, WHERE SHE WAS PLACED IN THE CENTER OF THE ROOM AND *HELD COURT* FOR THE HUNDREDS OF GUESTS.

INTERVIEWED BY *TIME MAGAZINE* SHORTLY AFTER THE OPENING, FRIDA REMAINED DEFIANT UNTIL THE END...

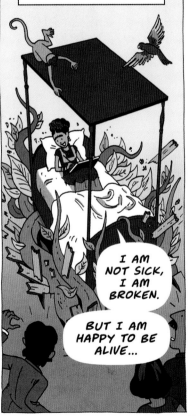

I AM NOT SICK, I AM BROKEN.

BUT I AM HAPPY TO BE ALIVE...

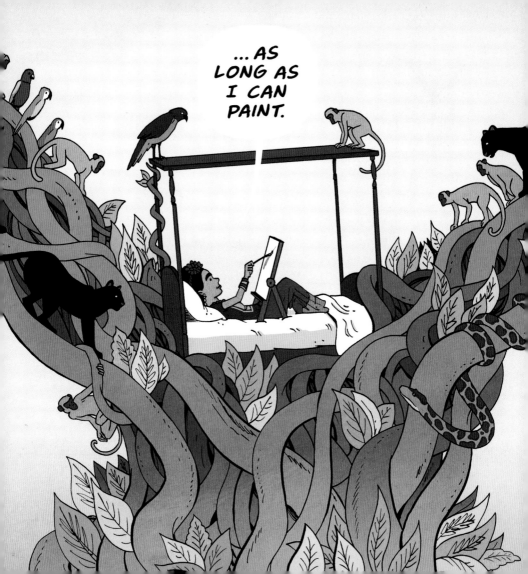

By all accounts, the young Frida Kahlo's career plan was to become a doctor. She was a bright young woman and attended Mexico's prestigious National Preparatory School where she was only one of thirty-five female students among two thousand. She was in her senior year and making plans to attend medical school when the fateful day of the bus accident occurred. Trapped in bed for months, she reevaluated not only herself but the world around her. With the help of a mirror placed above her bed, Frida began painting self-portraits, something she would do for the rest of her life, constantly examining herself and looking inward. After the tragedy of the accident, Frida was reborn and had found new life in painting: *"From that time my obsession was to begin again, painting things just as I saw them with my own eyes and nothing more."*

It's an origin story befitting a superhero, and Frida continued to live a heroic life despite decades of more agony and suffering (shortly after her exhibition, her right leg had to be amputated below the knee due to gangrene). So next time you complain that you don't know what your passion is or are wondering where to apply your creativity, count your blessings you didn't have go through a horrifying bus accident to find some clarity.

HEMINGWAY
A Lonely Life

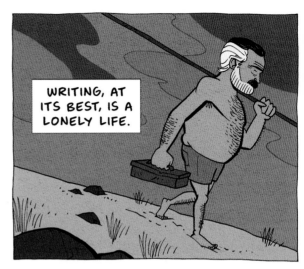

WRITING, AT ITS BEST, IS A LONELY LIFE.

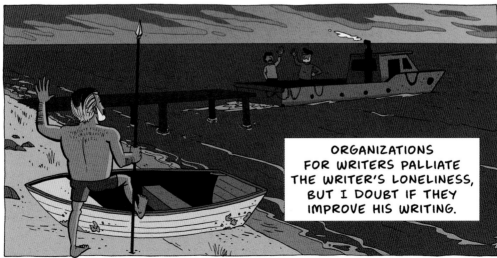

ORGANIZATIONS FOR WRITERS PALLIATE THE WRITER'S LONELINESS, BUT I DOUBT IF THEY IMPROVE HIS WRITING.

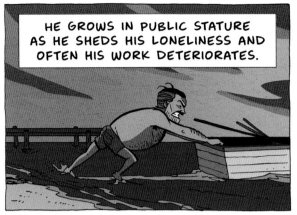

HE GROWS IN PUBLIC STATURE AS HE SHEDS HIS LONELINESS AND OFTEN HIS WORK DETERIORATES.

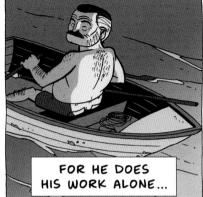

FOR HE DOES HIS WORK ALONE...

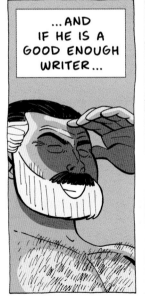

...AND IF HE IS A GOOD ENOUGH WRITER...

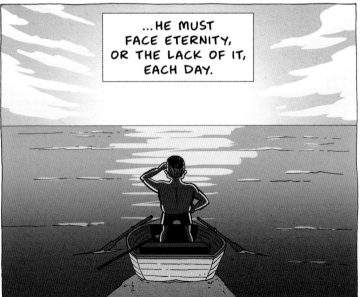

...HE MUST FACE ETERNITY, OR THE LACK OF IT, EACH DAY.

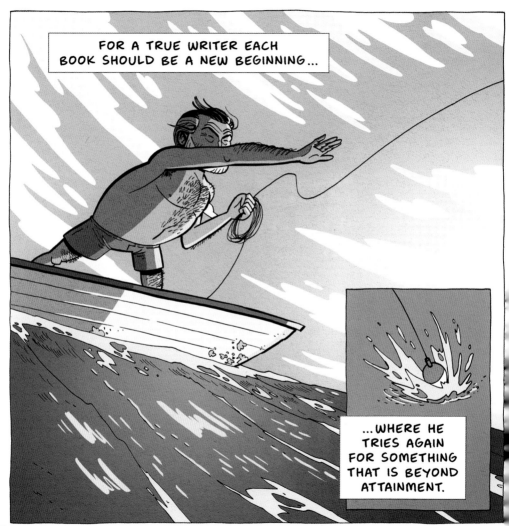

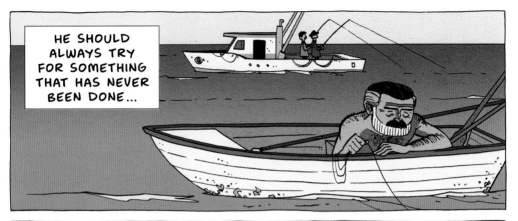

HE SHOULD ALWAYS TRY FOR SOMETHING THAT HAS NEVER BEEN DONE...

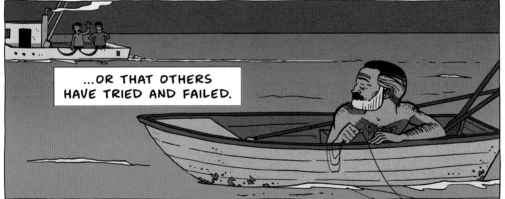

...OR THAT OTHERS HAVE TRIED AND FAILED.

THEN SOMETIMES...

PLOP

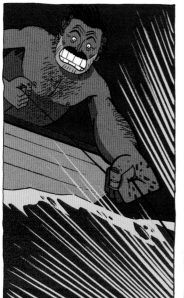

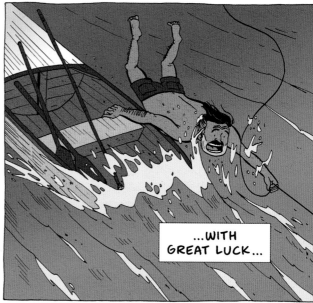

...WITH GREAT LUCK...

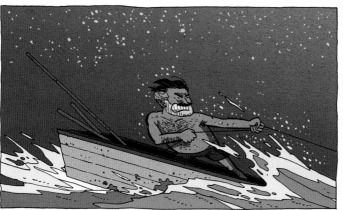

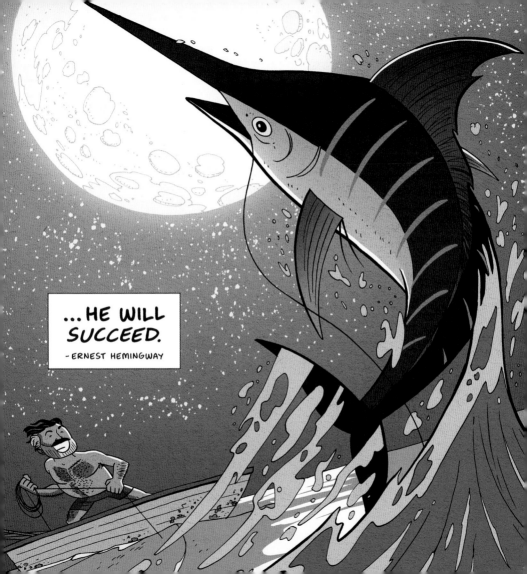

Ernest Hemingway hadn't written a successful novel in a decade. His previous novel, *For Whom the Bell Tolls* (1940), had become a classic and he was excited about the publication of his new novel *Across the River and Into the Trees* (1950). Upon its release, however, it was universally savaged by critics. It was Hemingway's first "failure" as a writer, and he was deeply upset by the reception. He was also pissed off. Critics were calling him washed up and finished. Hemingway was eager to prove them wrong.

He had lived an extraordinary life. One of the world's most famous writers, his personal exploits had become as renowned as his work. Hemingway saw action in both world wars, lived in Paris as part of the "lost generation" where he mingled with the great artists and writers of his time, immersed himself with the bullfighting culture of Spain, was a field reporter during the Spanish Civil War, lived and partied in Cuba, drank with movie stars, hunted big game in Africa, loved to box, and had been married four times. Perhaps the fame had affected his writing. Perhaps by shedding his loneliness, his work had deteriorated.

Hemingway knew he wasn't washed up and was determined to have his next book reclaim his throne as the King of American Writers. For the story, he went back to an idea that he had been toying with for years. Inspired by his time fishing in the Gulf of Mexico (Hemingway was a world-class sport fisherman) and the grizzled old

captain of his boat, he started writing a story of an old fisherman's epic battle with a giant marlin. Fuelled by his naysayers, he finished the novella in eight weeks.

Despite his full schedule of manly activities, drinking, and parties, writing always came first to Hemingway. He would wake at first light every day and usually start writing by 6 a.m. and be done by noon, always making sure to stop when *"you come to a place where you still have your juice and know what will happen next."* When Hemingway submitted the finished manuscript to his editor, he wrote, *"I know that this is the best I can write ever for all of my life."*

The Old Man and the Sea was initially published in *Life* magazine in 1952. The magazine's print run of 5.3 million copies sold out in TWO days. The subsequent book was on the bestseller list for six months. It won the Pulitzer Prize for Fiction the following year and Hemingway won the Nobel Prize in Literature in 1954. The King had regained his crown.

CREATIVE PEP TALK #3
The Cartoonist

I've been making comics full-time for the *Zen Pencils* website for six years now. Previously, I worked in the corporate world so it's taken some time to adjust to living an "artistic" life. What follows are a few tips that I've learned over the years that help me during my creative process. I might not adhere to these tenets one hundred percent of the time, but they're something I constantly strive to follow.

And yes, I realize the arrogance of putting myself in amongst the masters of creativity that preceded this entry. I wanted to call the book *CREATIVE STRUGGLE: Illustrated Advice from Masters of Creativity and One Not-So-Creative Cartoonist,* but my editor didn't like that.

A DAY IN THE LIFE OF AN INSECURE CARTOONIST

These are eight tips that help me overcome my own creative struggle.

1. ROUTINE IS SEXY

MOST PEOPLE THINK AN ARTIST'S PROCESS IS **SPONTANEOUS** AND **MAGICAL**, BUT IN MY EXPERIENCE A STRICT ROUTINE AND DISCIPLINE ARE THE KEYS TO CREATIVE WORK.

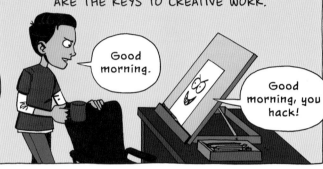

Good morning.

Good morning, you hack!

THE ONLY WAY TO SILENCE THE **INNER CRITIC** IS BY CONSTANTLY FLEXING YOUR **CREATIVE MUSCLES**.

IMPOSTER! IMPOSTER!

GETTING NEW IDEAS IS DIRECTLY PROPORTIONAL TO THE AMOUNT OF WORK YOU PUT IN, SO BE DEDICATED ENOUGH TO MAINTAIN A REGULAR SCHEDULE. **SHOWING UP REALLY IS THE HARDEST PART.**

Quiet you.

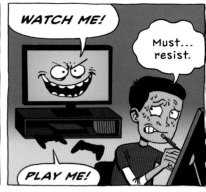

2. DISTRACTIONS ARE THE DEVIL

BE MILITANT ABOUT **MINIMIZING DISTRACTIONS**. EACH TIME YOU INTERRUPT YOUR WORK TO GET A SOCIAL MEDIA, NETFLIX, YOUTUBE, OR VIDEO GAME FIX, YOUR CREATIVE MUSE SMACKS HER HEAD IN FRUSTRATION.

3. AVOID COMPARISON

HAVING **ROLE MODELS** THAT INSPIRE YOU IS GREAT, BUT CONSTANTLY COMPARING YOURSELF TO OTHERS THAT ARE **MORE TALENTED, SUCCESSFUL, OR HAVE MORE FACEBOOK LIKES THAN YOU IS POINTLESS.** AS LONG AS YOU ARE IMPROVING AND PUSHING YOURSELF, YOU ARE ON THE RIGHT TRACK.

4. LET YOUR MIND WANDER

IF NOTHING CONSTRUCTIVE IS HAPPENING AT YOUR WORKSPACE, **GIVE YOUR MIND A LITTLE BREAK.** TRY GOING FOR A WALK (THIS WAS BEETHOVEN'S FAVORITE WAY TO BOOST HIS CREATIVITY), HAVING A SHOWER, OR MEDITATING. **EINSTEIN** WOULD DO THOUGHT EXPERIMENTS WHEN TRYING TO FIGURE OUT A PROBLEM...

...**NIKOLA TESLA** DID ALL HIS PROBLEM-SOLVING MENTALLY, AND **MARY SHELLEY** HAD HER FLASH OF INSPIRATION FOR FRANKENSTEIN WHEN IN A SEMI-DREAM STATE.

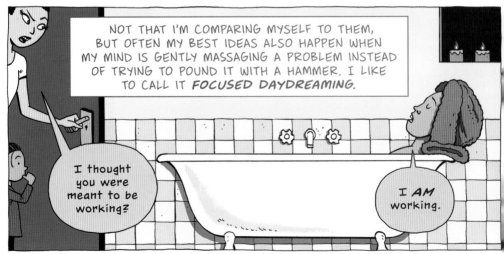

138

5. THE WORK IS THE REWARD

DON'T FOCUS ON **BECOMING FAMOUS, WINNING AWARDS, MAKING MONEY, OR GETTING FACEBOOK LIKES.** CHASING THE POT OF GOLD AT THE END OF THE RAINBOW IS NOT A SUSTAINABLE WAY TO CREATE. YOU HAVE TO LOVE THE **TORTUOUS, PAINFUL, AND SOMETIMES BORING PROCESS.** YOU HAVE TO LOVE THE WORK ITSELF. YOU HAVE TO LOVE **THE STRUGGLE.**

THERE'S NOTHING QUITE LIKE **GETTING IN THE ZONE.** WHEN THE WORK IS FLOWING, HOURS PASS BY IN WHAT FEELS LIKE MINUTES AND YOU REACH A STATE OF **CREATIVE ZEN.**

I am one with the Matrix.

6. SET YOURSELF DEADLINES

WHETHER THEY'RE REAL OR SELF-IMPOSED, NOTHING MOTIVATES QUITE LIKE A LOOMING DEADLINE.

IF YOU'RE STARTING OUT, GIVE YOURSELF **SMALL** PROJECTS AND SET ACHIEVABLE DEADLINES YOU KNOW YOU CAN MEET.

I did it!

AND DON'T FORGET TO **REWARD YOURSELF** WHEN YOU DO REACH YOUR GOAL.

STARTING A PROJECT IS ALL WELL AND GOOD, BUT **FINISHING** IT IS MUCH MORE SATISFYING.

Now to share my masterpiece with the world!

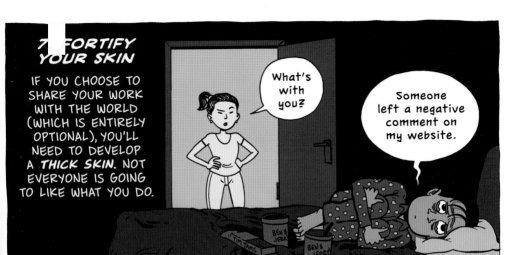

7. FORTIFY YOUR SKIN

IF YOU CHOOSE TO SHARE YOUR WORK WITH THE WORLD (WHICH IS ENTIRELY OPTIONAL), YOU'LL NEED TO DEVELOP A **THICK SKIN**. NOT EVERYONE IS GOING TO LIKE WHAT YOU DO.

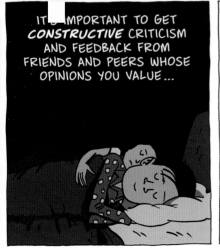

IT'S IMPORTANT TO GET **CONSTRUCTIVE** CRITICISM AND FEEDBACK FROM FRIENDS AND PEERS WHOSE OPINIONS YOU VALUE...

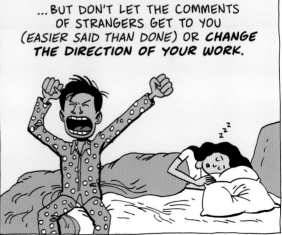

...BUT DON'T LET THE COMMENTS OF STRANGERS GET TO YOU (EASIER SAID THAN DONE) OR **CHANGE THE DIRECTION OF YOUR WORK.**

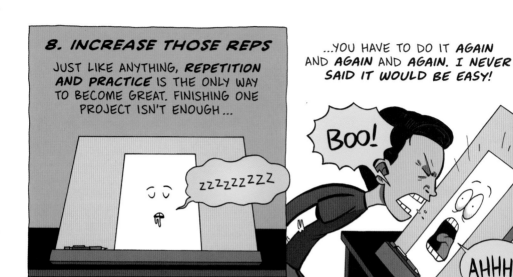

8. INCREASE THOSE REPS

JUST LIKE ANYTHING, **REPETITION AND PRACTICE** IS THE ONLY WAY TO BECOME GREAT. FINISHING ONE PROJECT ISN'T ENOUGH...

...YOU HAVE TO DO IT **AGAIN** AND **AGAIN** AND **AGAIN**. I NEVER SAID IT WOULD BE EASY!

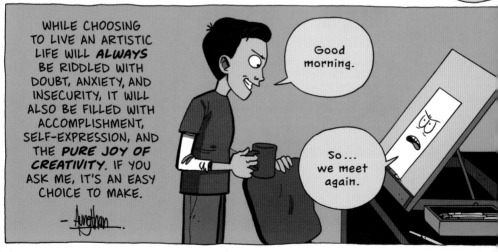

WHILE CHOOSING TO LIVE AN ARTISTIC LIFE WILL **ALWAYS** BE RIDDLED WITH DOUBT, ANXIETY, AND INSECURITY, IT WILL ALSO BE FILLED WITH ACCOMPLISHMENT, SELF-EXPRESSION, AND THE **PURE JOY OF CREATIVITY**. IF YOU ASK ME, IT'S AN EASY CHOICE TO MAKE.

Acknowledgments

Vincent van Gogh excerpts taken from *Letter to Theo van Gogh, October, 1884 in Nuenen; Letter to Theo van Gogh, 11 March 1883 in The Hague; Letter to Theo van Gogh, 21 July 1882.* Translated by Mrs. Johanna van Gogh-Bonger. © Van Gogh Museum, Amsterdam. *vangoghmuseum.com*

Personality rights of **Albert Einstein** are used with permission of The Hebrew University of Jerusalem. Represented exclusively by Greenlight.

Leonardo da Vinci excerpts taken from *The Notebooks of Leonardo da Vinci*, translated by Jean Paul Richter, originally published 1888.

Mary Shelley excerpt taken from her introduction to *Frankenstein; or, The Modern Prometheus*, 1831 edition. Originally published by Henry Colburn and Richard Bentley, London.

Marie Curie excerpts taken from *Pierre Curie: With Autobiographical Notes.* Translated by Charlotte and Vernon Kellogg, published by Macmillan, 1923, New York.

Jiddu Krishnamurti excerpt taken from *The Book of Life: Daily Meditations with Krishnamurti,* by J. Krishnamurti. Published by HarperOne. *Krishnamurti.org*

Ludwig van Beethoven excerpt taken from "Letter to Emilie M. 1812." Excerpt from Quote 54, in *Beethoven: The Man and the Artist, As Revealed in His Own Words* by Ludwig van Beethoven, edited by Friedrich Kerst and Henry Edward Krehbiel. Published by B. W. Huebsch, 1905.

Stephen King excerpt taken from *On Writing: A Memoir of the Craft* by Stephen King © 2000. Published by Scribner. *stephenking.com*

Share your
CREATIVE STRUGGLE

A novel, painting, song, film, dance, play, blog, experiment, building, sculpture, video game, cake . . . whatever it is you're working on, I would love to see your creative struggle!

Share your work-in-progress or finished project on social media using #creativestruggle and find me on Twitter or Instagram at @zenpencils.

I hope this book has helped in some small way with your own creative pursuit.

Now put it down and get to work!

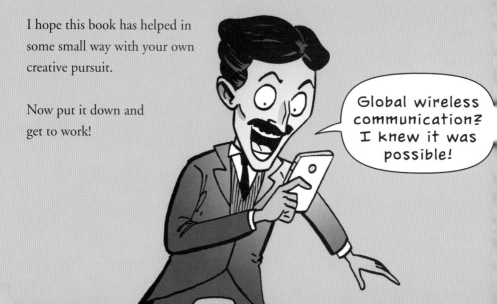

Global wireless communication? I knew it was possible!

Photo by Jessica Ong

Gavin Aung Than is a *New York Times*–bestselling cartoonist and creator of *Zen Pencils*, a cartoon blog which adapts inspirational quotes into comic stories. *Zen Pencils* has been featured by the *Washington Post*, BuzzFeed, Gawker, Brain Pickings, Upworthy, *VICE*, Mashable, and was named one of the top 100 websites of 2013 by PCMag. He lives in Melbourne, Australia with his wife and daughter. For more cartoon quotes from inspirational folks visit www.zenpencils.com